IRELAND

A visual journey around the counties of Ireland

Gill Books
Hume Avenue, Park West, Dublin 12

www.gillbooks.ie

Gill Books is an imprint of M.H. Gill & Co.

Text © Gill & Macmillan 2014
Design © Teapot Press Ltd 2014
For photography credits see p.128

ISBN: 978-0-7171-5743-3

This book was produced for Gill Books
by Teapot Press Ltd

Picture research by Jen Patton
Designed by Tony Potter

Printed in EU

This book is typeset in Dax

A CIP catalogue record for this book is available
from the British Library.

5 4

IRELAND

PROVINCES & COUNTIES

Ireland has historically been divided into four provinces: Leinster, Ulster, Munster and Connacht. The provinces of Ireland serve no administrative or political purposes, but function as historical and cultural entities. Each province is divided into counties.

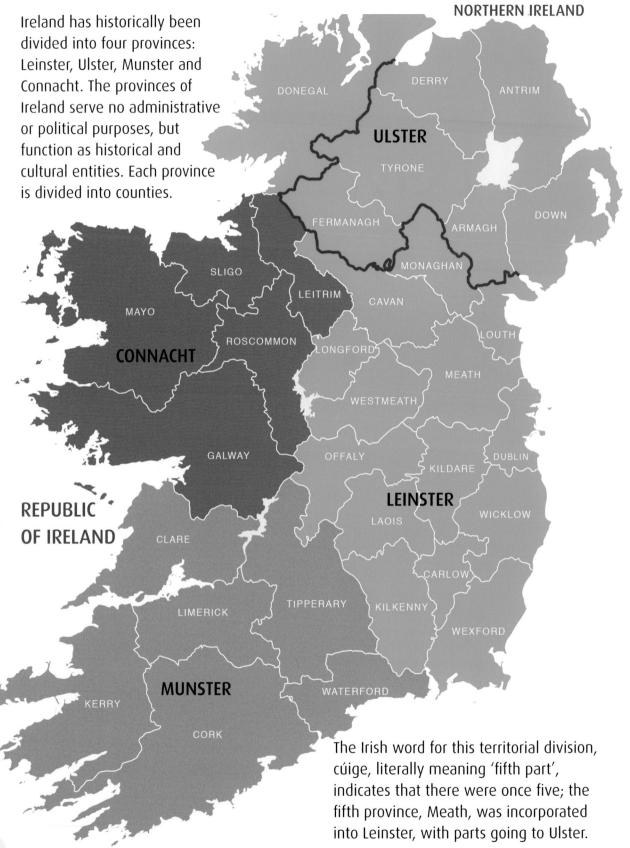

NORTHERN IRELAND

DONEGAL

DERRY

ANTRIM

ULSTER

TYRONE

DOWN

FERMANAGH

ARMAGH

SLIGO

MONAGHAN

LEITRIM

CAVAN

MAYO

LOUTH

ROSCOMMON

LONGFORD

CONNACHT

MEATH

WESTMEATH

REPUBLIC OF IRELAND

GALWAY

OFFALY

DUBLIN

KILDARE

LEINSTER

LAOIS

WICKLOW

CLARE

CARLOW

LIMERICK

TIPPERARY

KILKENNY

WEXFORD

MUNSTER

WATERFORD

KERRY

CORK

The Irish word for this territorial division, cúige, literally meaning 'fifth part', indicates that there were once five; the fifth province, Meath, was incorporated into Leinster, with parts going to Ulster.

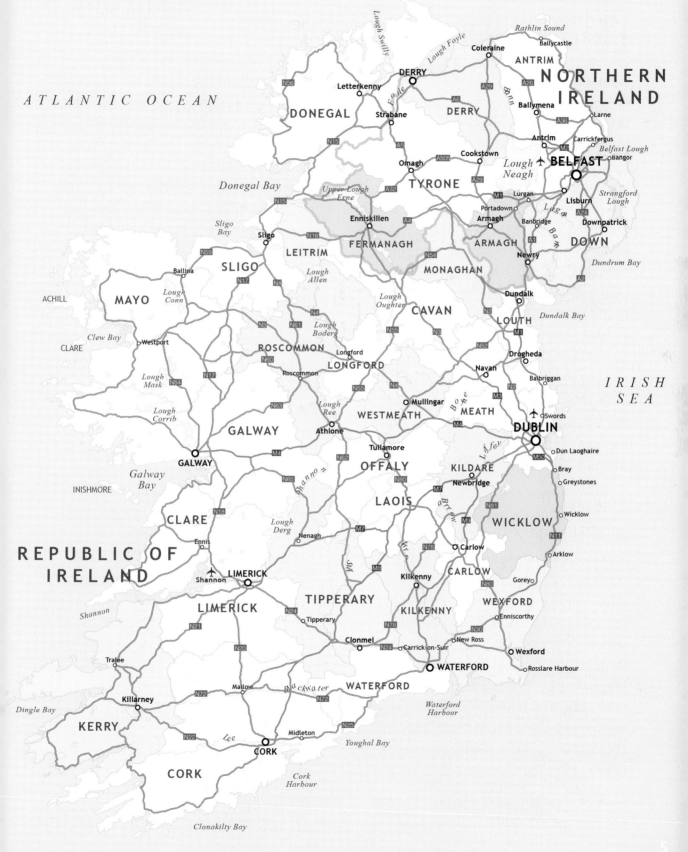

ATLANTIC OCEAN

Lough Swilly

Rathlin Sound
Ballycastle

Coleraine

ANTRIM

NORTHERN IRELAND

DERRY
Letterkenny

DONEGAL

Strabane

Foyle

Lough Foyle

A29
A6
DERRY

Ballymena

A26

A36
Larne

Antrim
Carrickfergus

Belfast Lough

M2
Bangor

BELFAST

Lough Neagh

Cookstown

Omagh
A505

TYRONE

A32

Donegal Bay

N56

N15

A5

Upper Lough Erne

Enniskillen

FERMANAGH

A4

A29

Lurgan

M1

Portadown
Armagh

Banbridge

Lisburn

A24

Downpatrick

Lagan

Strangford Lough

DOWN

ARMAGH

N54

Newry

A1

A2

Dundrum Bay

Sligo Bay

Sligo

LEITRIM

N16

Lough Allen

MONAGHAN

Bann

Dundalk

Dundalk Bay

N59
Ballina

N15

SLIGO

N17

Lough Conn

N4

Lough Oughter

CAVAN

N2

LOUTH

N52

M1

ACHILL

MAYO

Lough Conn

N5

N61

Lough Boderg

N55

N3

Drogheda

IRISH SEA

CLARE

Clew Bay

Westport

ROSCOMMON

N60

Longford

LONGFORD

N4

Navan

N2

Balbriggan

Lough Mask

N84

N17

Roscommon

N55

Boyne

MEATH

Lough Corrib

N63

Lough Ree

Mullingar

WESTMEATH

M4

Swords

DUBLIN

GALWAY

Athlone

M3

Galway Bay

GALWAY

M4

N62

Tullamore

OFFALY

N65

Shannon

N80

Newbridge

KILDARE

M7

Dun Laoghaire

M50

Bray

Greystones

INISHMORE

LAOIS

Barrow

N81

WICKLOW

Wicklow

CLARE

N18

Lough Derg

Ennis

Nenagh

M7

N78

Carlow

Nore

Arklow

N11

REPUBLIC OF IRELAND

Shannon

LIMERICK

TIPPERARY

Suir

M8

Kilkenny

CARLOW

Gorey

LIMERICK

N24

Tipperary

KILKENNY

WEXFORD

Enniscorthy

N21

N20

Clonmel

N24

Carrick-on-Suir

N76

New Ross

N30

Tralee

Mallow

N72

Blackwater

WATERFORD

WATERFORD

Wexford

Rosslare Harbour

Dingle Bay

Killarney

N72

Waterford Harbour

KERRY

N22

N25

Midleton

Youghal Bay

Lee

CORK

CORK

Clonakilty Bay

Cork Harbour

LEINSTER

Leinster is the largest of the four provinces by number of counties, but only the third largest by area. With the River Shannon as its western boundary, it occupies the midlands and south-east of the island. While there are large areas of bogland in the midland counties, for the most part the province is fertile. This is especially the case in the flat grazing country close to Dublin, in counties Kildare and Meath, and in the river valleys of the south-east. Immediately to the south of the capital, however, the coastal county of Wicklow is dominated by its mountainous terrain. Historically, it used to be regarded as a fastness for Gaelic insurgents who represented a threat to the small city. In more recent times, it has become a playground on the city's southern margins: the garden of Ireland.

The province, like the island itself, is dominated by the capital. Dublin is home to one in three of the Republic's population. It is the political, administrative, legal, cultural and educational focal point of the state. For a thousand years, it has been the largest centre of population on the island. Originally of Viking foundation, it owes its pre-eminence to two inter-related facts: it offers one of the best harbours for shipping on the east coast and it commands the shortest and most convenient crossing to Britain.

As with many other capitals, this has conditioned attitudes. Dubliners are inclined to regard the rest of the population as provincials ('culchies' in the local argot, denoting someone from a remote or rural area). In turn, the 'culchies' give as good as they get, referring to Dubliners as 'jackeens' meaning 'Little Jacks' ('Jack' being the familiar name of John Bull, a nickname for an Englishman). In short, Dublin has a taint of being a bit English and by extension not quite Irish enough.

This is all good fun but like all caricatures it contains a semblance of truth. Modern Dublin – that is the classical city that emerged from the late 17th century onward – was the creation of an English colonial elite, newly settled in Ireland following the final subjugation of the island to English power by Cromwell. This elite gradually developed a kind of colonial nationalism, rather in the way of the English in North America or the Spanish in South America. But the Americas were very far away from Europe, and Ireland is very close to England. The Anglo-Irish always remained a hyphenated tribe. While their contribution to Ireland is incalculable, their emotional connection to England was never broken.

Indeed, when modern Irish nationalism developed in the wake of the French Revolution, it was distinguished by one overwhelming fact. Most of its adherents were Catholics, nursing a sense of dispossession that went back to the land confiscations under Cromwell

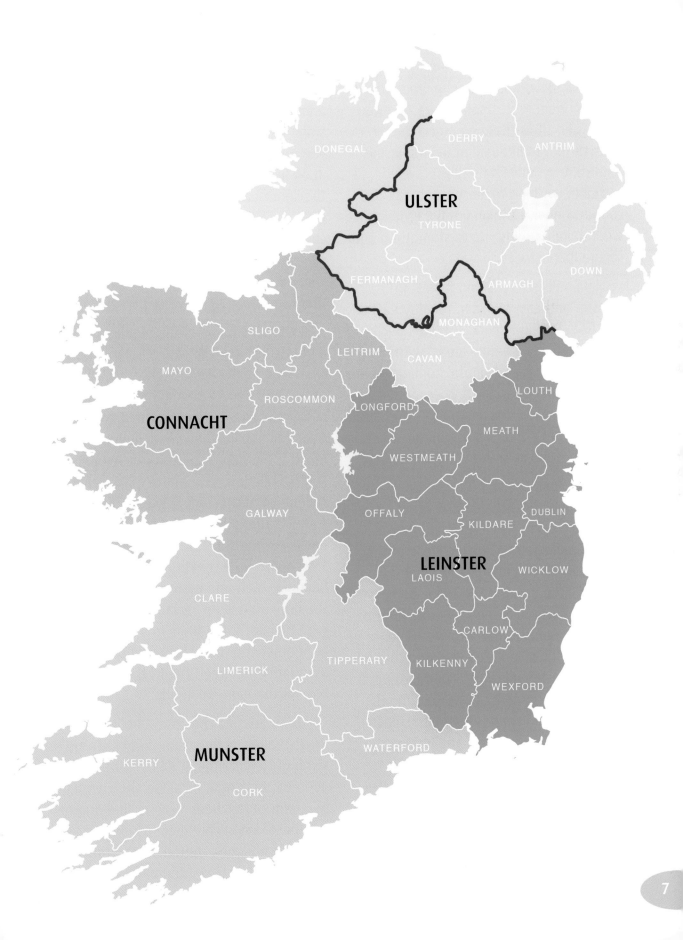

ULSTER

DONEGAL
DERRY
ANTRIM
TYRONE
DOWN
FERMANAGH
ARMAGH
MONAGHAN

CONNACHT

SLIGO
MAYO
ROSCOMMON
LEITRIM
CAVAN
LOUTH
LONGFORD
MEATH
WESTMEATH
GALWAY
OFFALY
DUBLIN
KILDARE
LEINSTER
WICKLOW
LAOIS
CLARE
CARLOW
LIMERICK
TIPPERARY
KILKENNY
WEXFORD
MUNSTER
WATERFORD
KERRY
CORK

nearly 200 years earlier. The Anglo-Irish landlords, descendants of the Cromwellian settlers, were Protestants of the Anglican confession. Thus there emerged the binary division that marked all of Ireland in the 19th century: most nationalists were Catholics, wishing to loosen or break the connection with England; most Protestants were unionists, wishing to strengthen and secure the connection.

Nationalism developed fastest in Leinster and east Munster, roughly east of a line from Dublin to Cork. This was because these relatively wealthy areas, with good land and bigger agricultural holdings, were more advanced socially and economically. There were more towns and the structures of the Catholic Church were in much better shape there than in the west of Ireland.

For all that, Leinster has less of a coherent personality than the other three provinces. Ulster has its own particular set of differences. When we think of that land of myth and imagination that we refer to simply as the West of Ireland, we are effectively thinking of the province of Connacht. Munster has a ferocious sense of its own distinctiveness, expressed through sport – hurling and rugby – and through a defiant swagger that allows Cork to refer to itself as the People's Republic. Leinster has none of these things and little sense of provincial integrity.

Perhaps it is just too sprawling. It contains 12 counties, more than any other province, and runs from the foothills of south Ulster westward to the River Shannon and down to the south-east corner of the island in Co. Wexford. That's a lot of varied territory on an island where small local differences can loom large. The midland counties feel alike, but not at all like the river valleys and coasts of the south-east; yet they are all under the Leinster umbrella. Or perhaps Dublin simply subsumes and resolves the province's contradictions. Either way, there is little sense of a Leinster personality similar to those in the other provinces.

It contains many of the highlights that a visitor will want to see in Ireland. Dublin is, of course, the most likely point of access and departure and has a number of outstanding highlights. The great Georgian squares have mercifully survived most of the depredations of developers. Trinity College is one of the most beautiful college campuses anywhere; its old library contains the great illuminated manuscript known as the Book of Kells. The Guinness Storehouse, in a converted old industrial building, is an impressive celebration of the drink that is universally associated with Ireland, sometimes to the chagrin of people who feel that too close an association between the Irish and booze is bad for the national image.

About 20 miles north of Dublin, in the Boyne Valley, is the astonishing passage tomb of Newgrange. It dates from about 3000 BC, making it as old as the Egyptian pyramids. It has been justly called one of the most famous prehistoric monuments in Western Europe. To the south of the city, deep in the Wicklow Mountains, is the

beautiful valley of Glendalough, containing the impressive ruins of a monastic site that dates back to its origins in the seventh century. Further south again, on the banks of the River Nore, the compact city of Kilkenny is a delight, and the small towns and villages further down the Nore are full of quiet charm and personality. It is not a corner of Ireland most readily associated with tourism in people's minds, but it is well worth spending some time there.

In all, therefore, Leinster is a varied province with an elusive, hard-to-pin-down feel to it. Dublin is obviously the dominant feature but you can still travel to corners of the province where you feel a long way from Dublin – at least mentally if not geographically.

Sunset on the lower Liffey, Dublin.

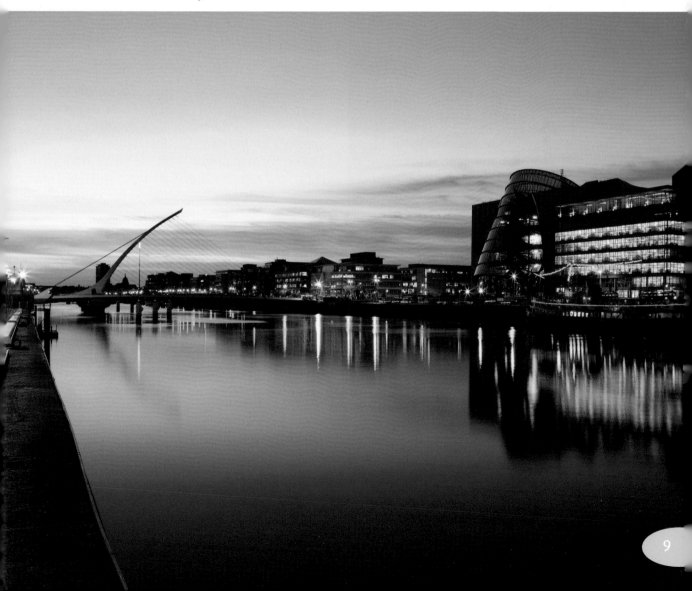

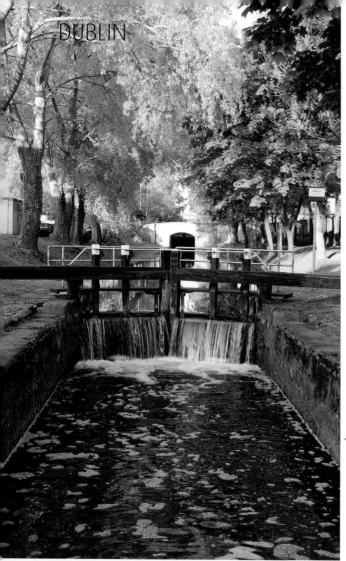

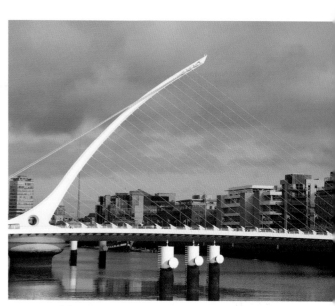

Designed by Santiago Calatrava, the Samuel Beckett Bridge on the lower reaches of the Liffey is one of the most dramatic additions to the city landscape. ▲

◄ *Dublin's Grand Canal is not particularly grand, but it is full of charm, especially on the stretch between Leeson Street Bridge and Mount Street Bridge.*

The city is justly famous for its pubs, such as this one, The Temple Bar, in the heart of the leisure district of the same name. ▼

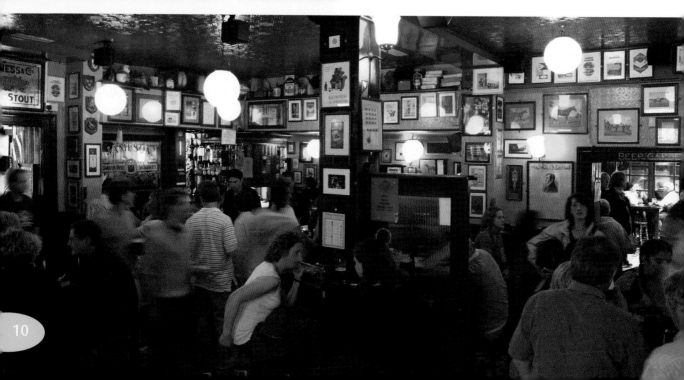

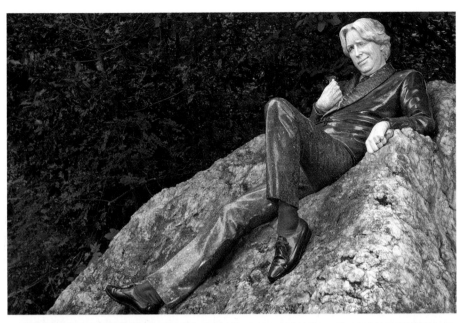

This splendid memorial to Oscar Wilde, the work of Danny Osborne, adorns the north-west corner of Merrion Square.

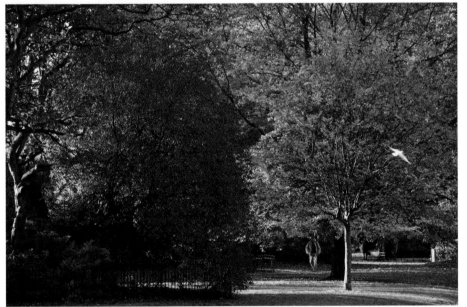

St Stephen's Green, the best loved of the city's parks.

The magnificent West Front of Trinity College dates from 1759.

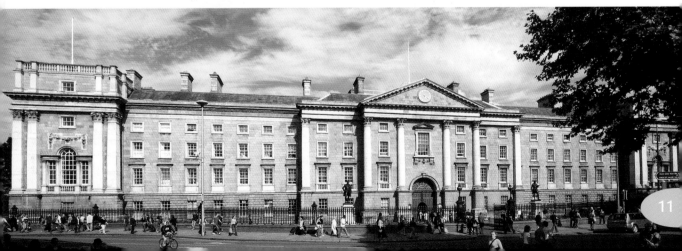

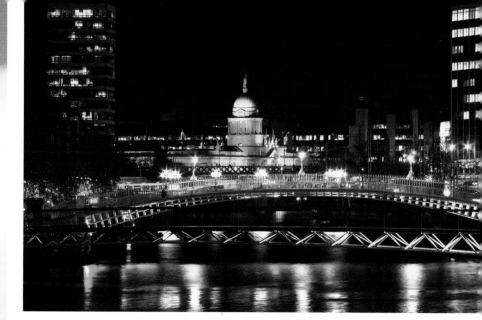

The River Liffey at night, looking downriver. In the foreground is the Millennium Bridge with the Ha'penny Bridge curving behind it. The Custom House is centred in the distance flanked on the left by Liberty Hall and on the right by O'Connell Bridge House. ▲

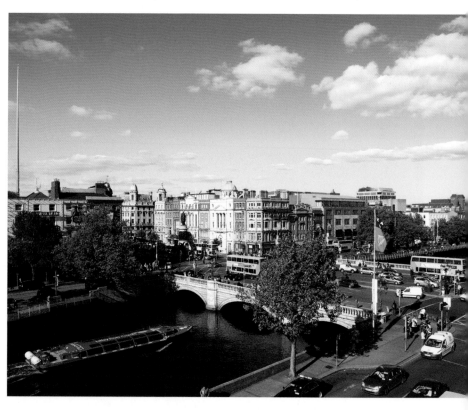

The Spire, standing where Nelson's Pillar stood until it was blown up in 1966. The Spire has divided opinion, to put it mildly. ◄

O'Connell Bridge in the heart of the city. It has the unusual characteristic of being as broad as it is long. ►

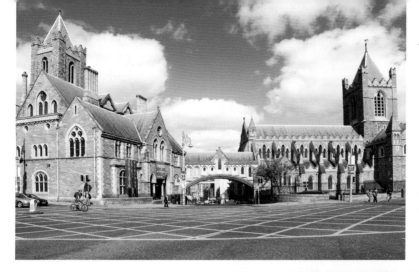

Christ Church Cathedral, in the heart of the old Viking city. The present building is largely a 19th-century restoration – and the chapter house on the left and the connecting bridge were only built as part of that process. The tower standing proud at the left is not part of the cathedral, but of the adjacent church of St Audeon.

Temple Bar is the city's leisure playground and a Mecca for tourists. It is compact and almost completely traffic-free. Prior to its creation in the 1980s, it was a derelict area and is a symbol of urban renewal and of the city's future potential. ▶

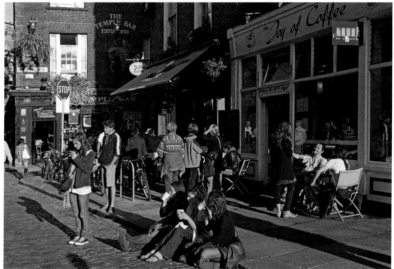

The General Post Office in O'Connell Street was the headquarters of the leaders of the 1916 Easter Rising, which began the process that led to Irish independence. ▼

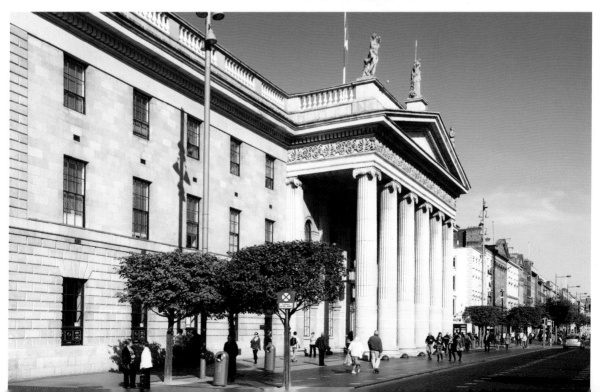

DUBLIN

The Boer War memorial to the men of the Royal Dublin Fusiliers at the principal entrance to St Stephen's Green. Because the RDF fought for the British Army, it is sometimes unkindly referred to as Traitors' Gate. ◄

Sunset on the lower Liffey, with the Samuel Beckett Bridge on the left and the angled drum of the National Conference Centre on the right. ▼

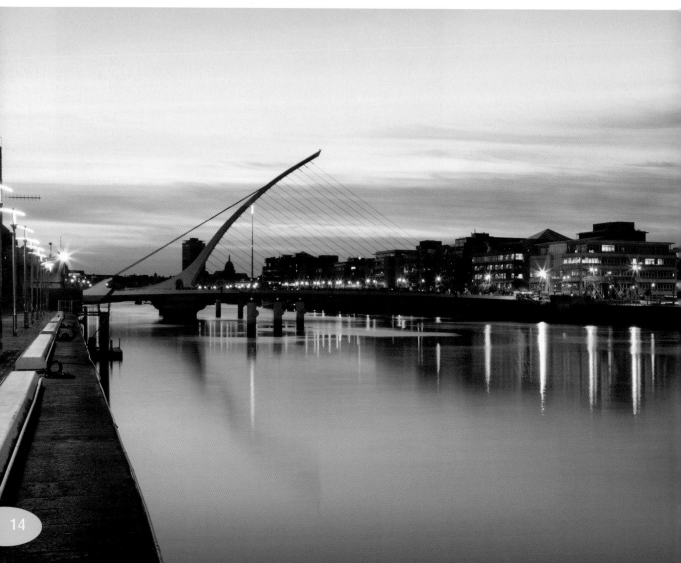

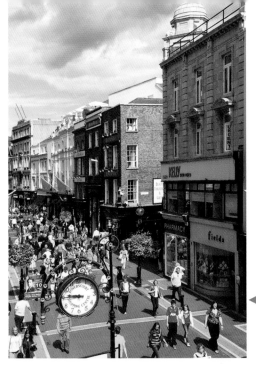

◄ *Grafton Street, the most fashionable shopping street in the city.*

▲ *Georgian elegance.*

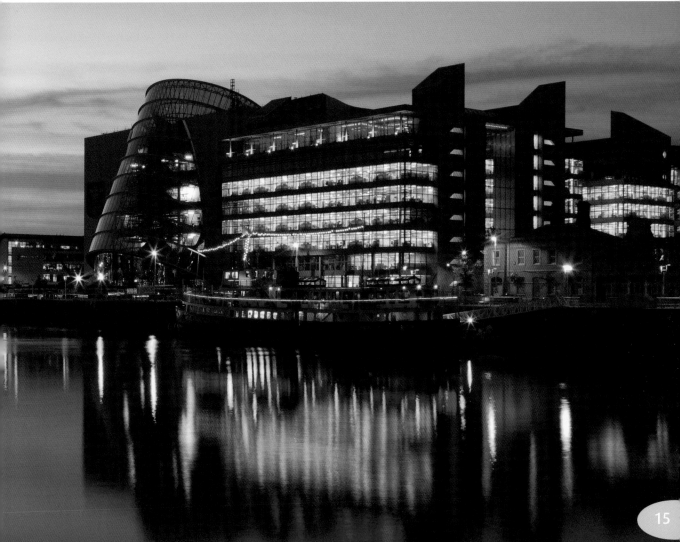

DUBLIN

Government Buildings in the heart of Dublin. Originally built to house the Royal College of Science, it was the last major public building constructed in British days. It dates from 1911 and was extensively restored and updated in the 1980s.

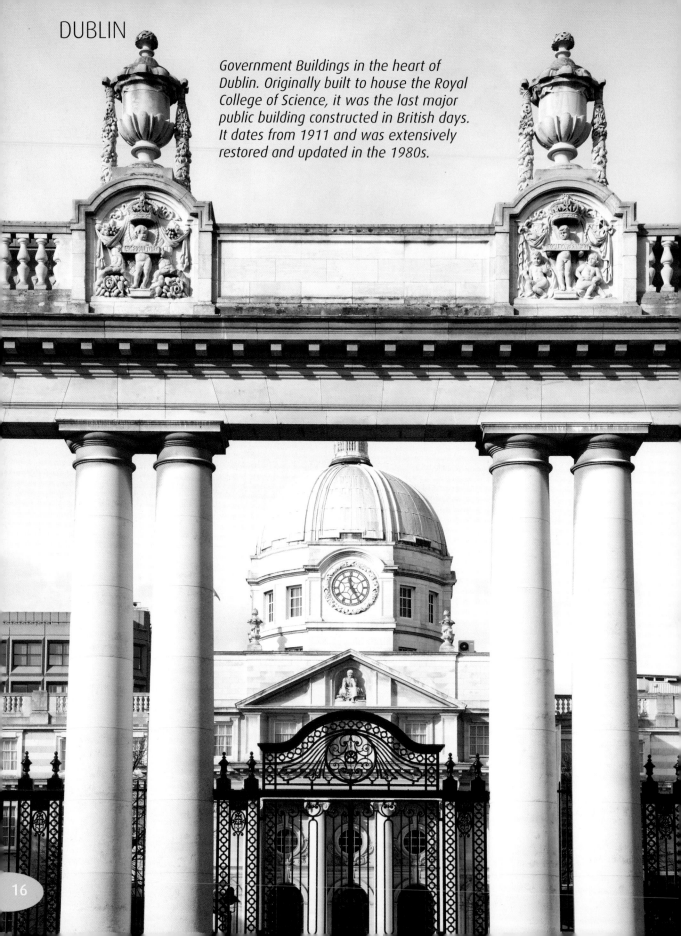

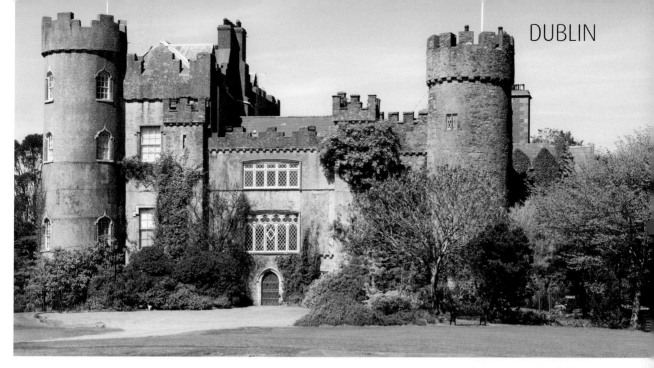

▲ Malahide Castle to the north of the city was for centuries home to the Talbot family, one of the most influential of the Hiberno-Norman families that settled in Ireland from the 12th century.

This statue of the late Phil Lynott, lead singer and guitarist with Thin Lizzy, remembers one of Dublin's best-loved rock musicians. ▶

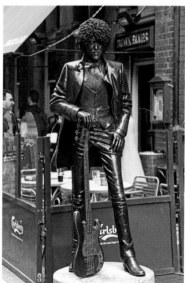

A striking view of Howth Harbour. The village and suburb of Howth stands at the end of the northern arm of Dublin Bay. It is a fishing port as well as a popular venue for leisure sailing, as can be seen from the marina in the foreground. In the background stands the island of Ireland's Eye.

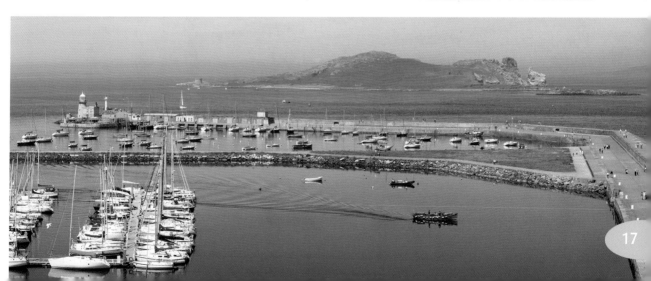

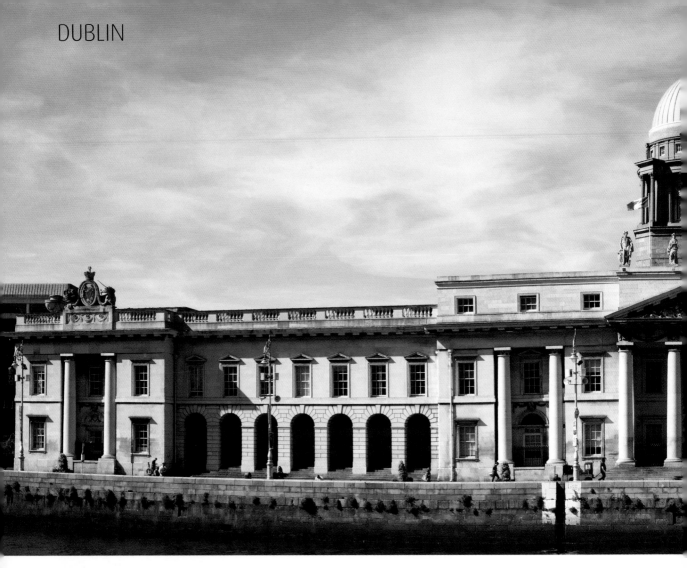

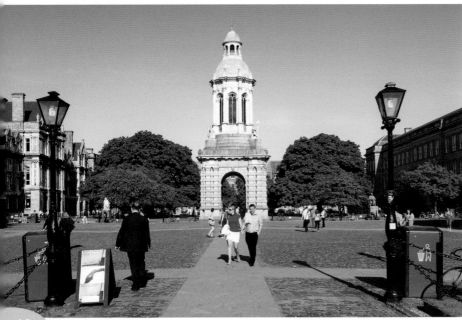

In the opinion of many, ▲ James Gandon's Custom House (1791) is the finest classical building in Dublin. It stands downstream on the north bank of the Liffey.

◄ Front Square in Trinity College. The campanile is in the centre, flanked on the left by the Graduates' Memorial Building and on the right by the Old Library, which holds the Book of Kells.

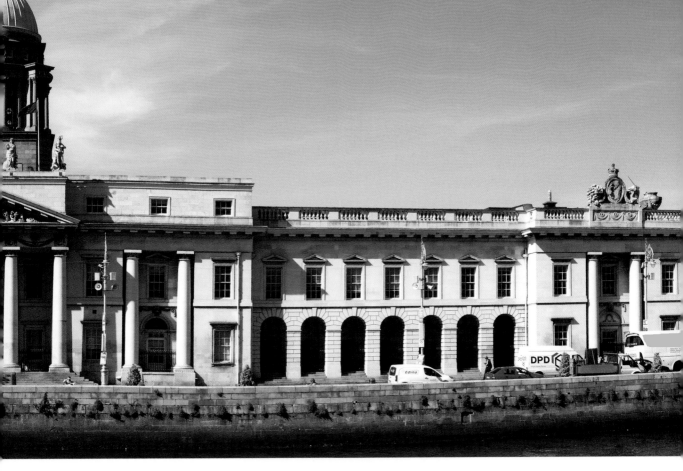

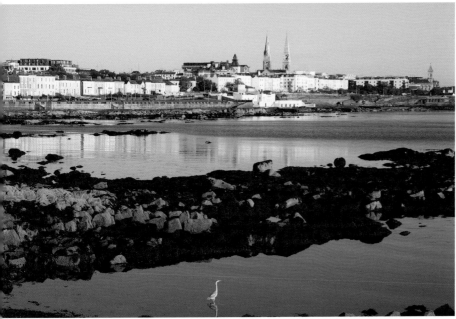

Dún Laoghaire, a prosperous suburb and ferryport to the south of the city. It was formerly called Kingstown to commemorate the visit of King George IV in 1821. Unfortunately, the king was so drunk that he could not be put ashore lest his condition scandalise the waiting crowd, so he was taken over to Howth on the far side of the bay and sneaked ashore there.

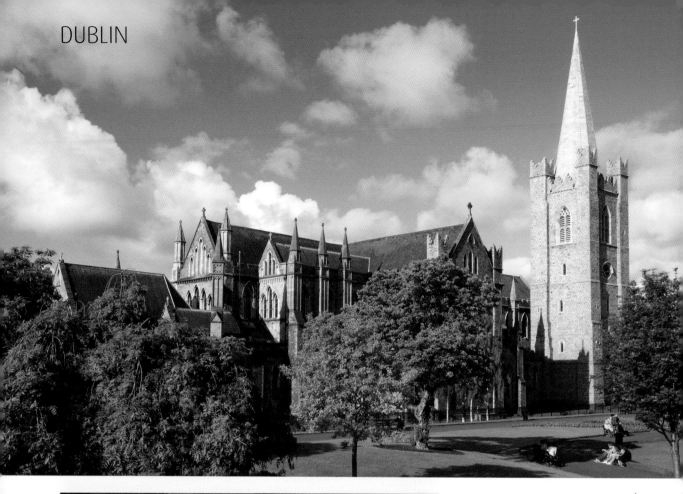

St Patrick's Cathedral, the principal cathedral of the Church of Ireland. Dating from the 13th century, it originally stood outside the old city walls.

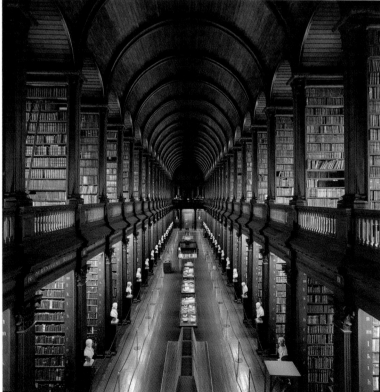

The stunning Long Room in the Old Library in Trinity, one of the world's great libraries. The original building (1712) had a flat roof. The barrel-vaulted ceiling, which really makes the building, was a Victorian addition. It is sobering to think that, under modern conservation rules, it would be forbidden today.

DUBLIN

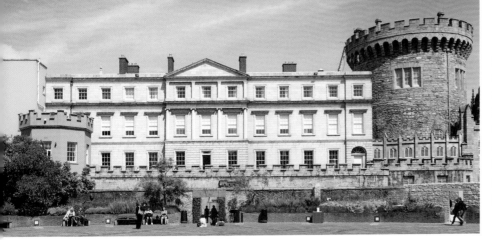

Dublin Castle, for centuries the nerve centre of British power in Ireland. It is more an eclectic collection of administrative buildings from different eras than a castle in the ordinary sense of the term.

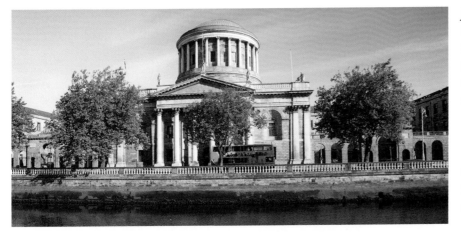

James Gandon's great Dublin masterpiece, the Four Courts, stands upriver of the city centre on the north bank of the river.

Entrants in the Tall Ships' Race moored on the lower Liffey.

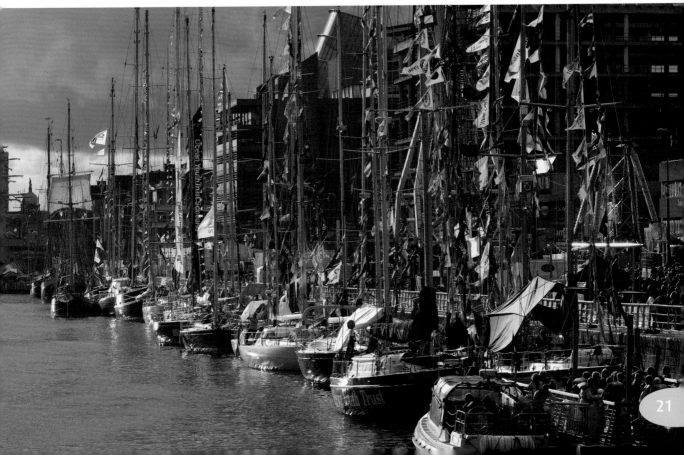

WICKLOW

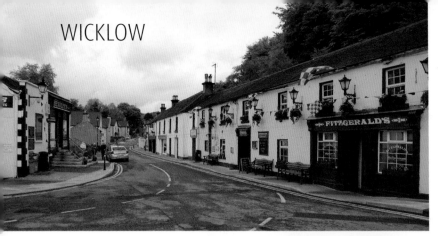

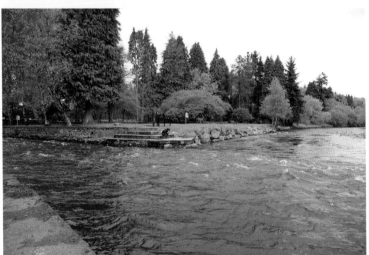

▶ *Avoca village in the heart of Co. Wicklow.*

Mount Usher Gardens in Ashford, Co. Wicklow, are a delight all year round. ▶

The Meeting of the Waters, the subject of one of Thomas Moore's most famous ballads: 'There is not in this wide world a valley so sweet/As the vale in whose bosom the bright waters meet'. The rivers are the Avonbeg on the left and the Avonmore on the right.

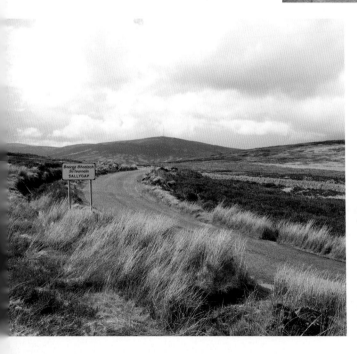

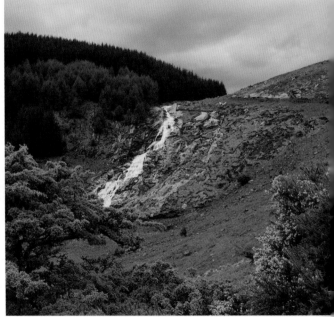

In the middle of the Wicklow Mountains, the Sally Gap is the point where four roads meet.

The waterfall at Glenmacnass. It is hard to believe that you are less than an hour's drive from the centre of Dublin.

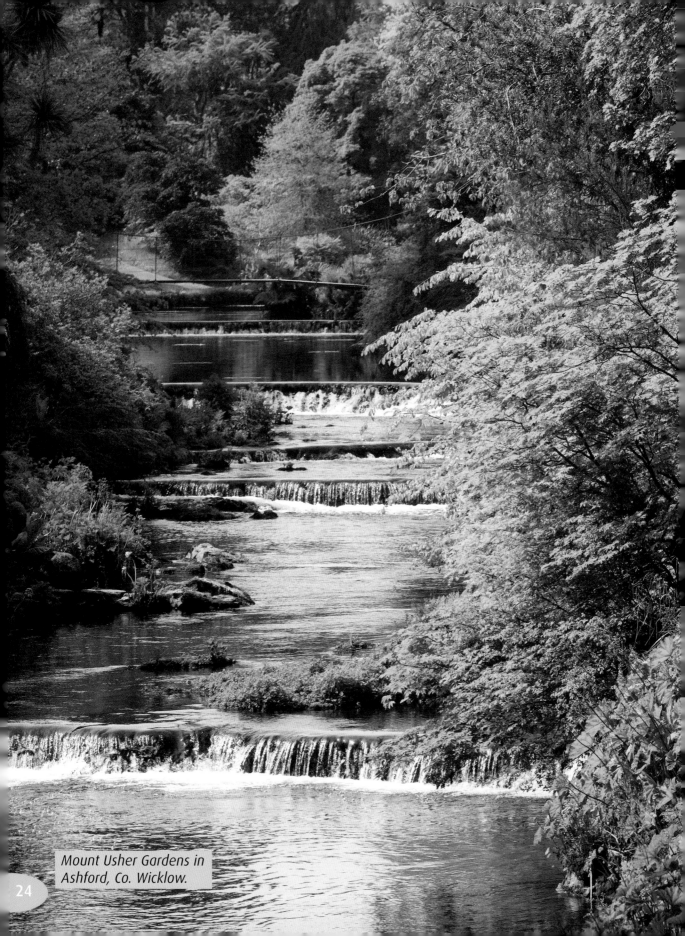

Mount Usher Gardens in Ashford, Co. Wicklow.

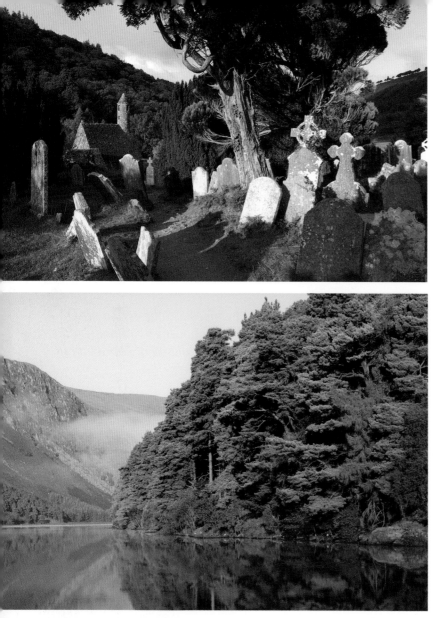

WICKLOW

Glendalough, in the heart of the Wicklow Mountains, is both a beautiful valley and an ancient monastic site.

The Upper Lake at Glendalough.

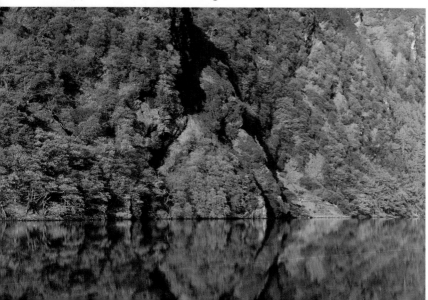

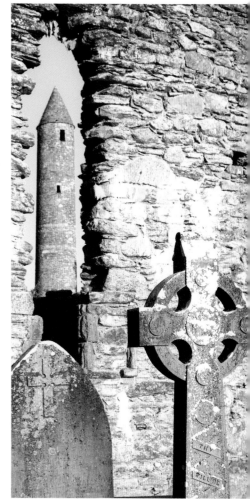

The round tower at Glendalough dates from the 10th century.

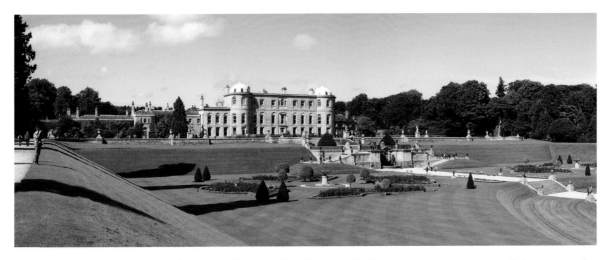

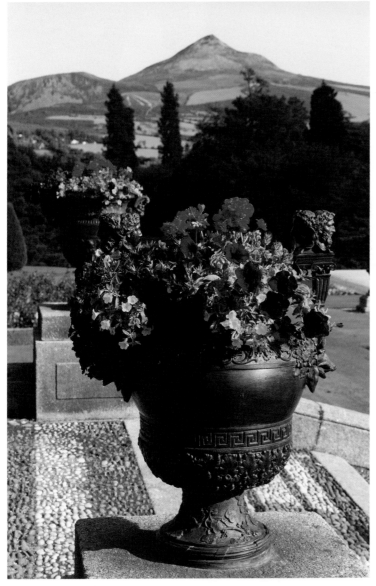

Powerscourt, one of the great ▲ country houses of Ireland, stands near the village of Enniskerry in north Co. Wicklow.

The view of the Great Sugar Loaf mountain from the front of Powerscourt.
◄

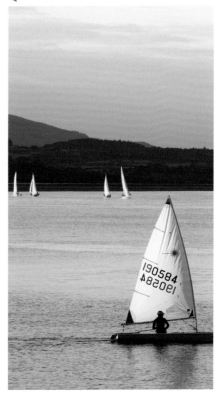

An evening scene at the harbour in Wicklow Town.

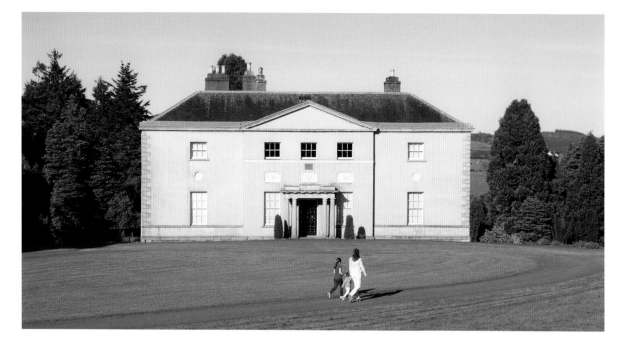

Avondale House, ancestral ▲
home of the patriot Charles
Stewart Parnell.

◄

Kilruddery House, near Bray,
was home to the Earls of Meath.

The main street in
Wicklow town. ▼

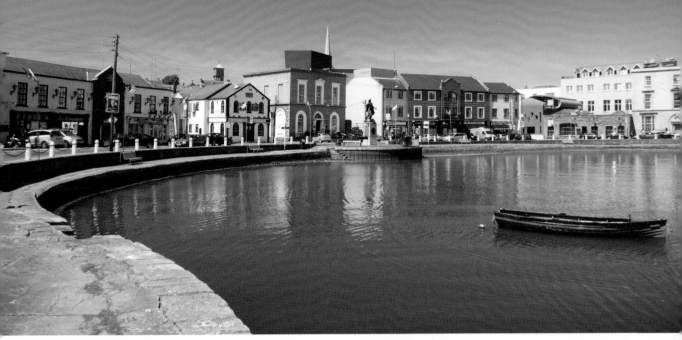

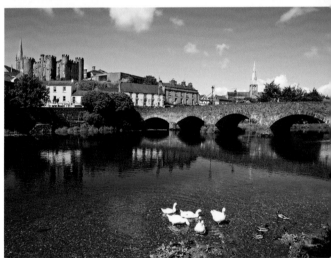

▲ The Crescent in the heart of Wexford town. Co. Wexford was the main location of the Irish rising of 1798 against British rule; the rebels held the town for nearly a month. Wexford stands at the mouth of the River Slaney. In the centre of the Crescent is a statue to Commodore James Barry (1745–1803), the 'father of the American navy', who was born not far from here. In this photograph, it can be seen silhouetted against the gable wall in the middle distance.

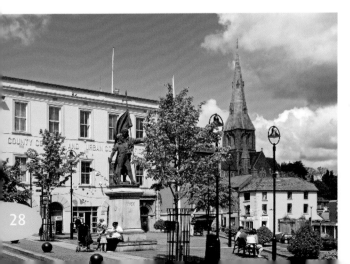

The town of Enniscorthy stands in the middle ▲ of Co. Wexford. On the slopes of Vinegar Hill, just above the town, the last and decisive battle of the 1798 rising was fought.

◀

The Hook Peninsula lies at the southern tip of Co. Wexford and its lighthouse is a feature of this remote but beautiful area.

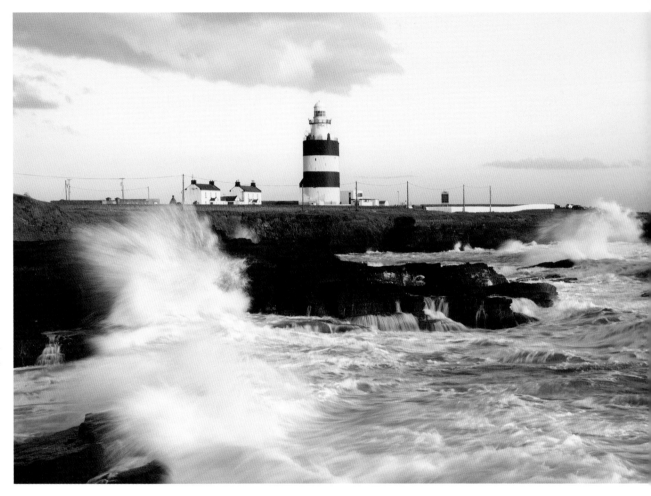

Thatched cottages in the pretty village of Kilmore Quay.

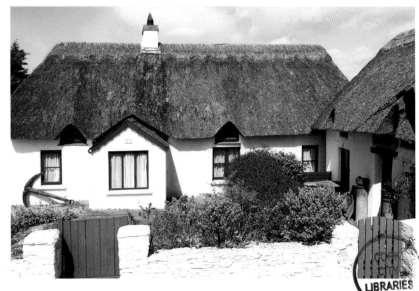

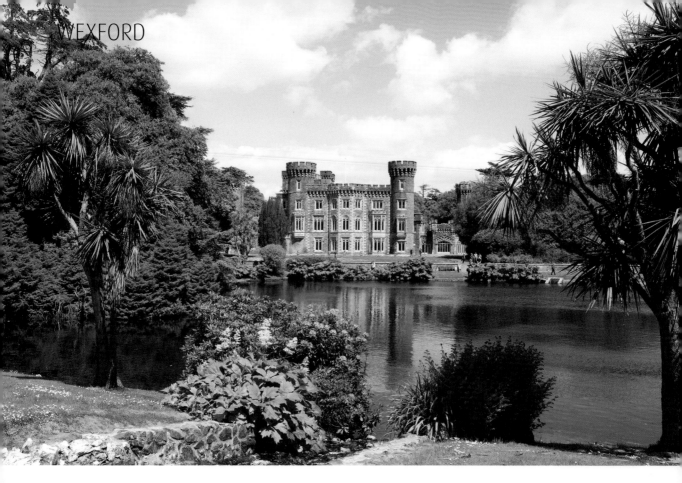

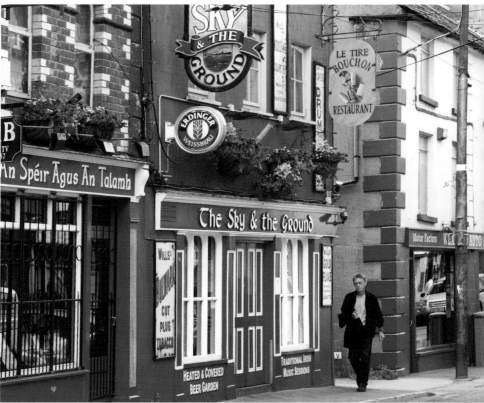

▲ Johnstown Castle is now home to the Irish Agricultural Museum. It was originally built as a country house residence in the early 19th century in the then fashionable Gothic revival style.

Shopfronts in Wexford town. ▶

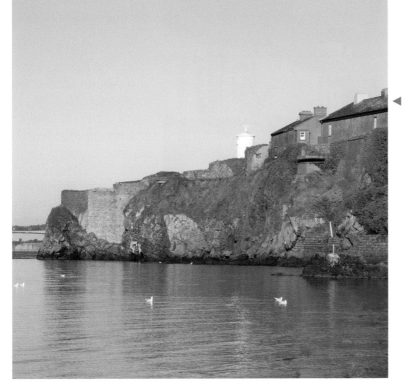

Duncannon, on the Wexford side of the estuary, is a fortification originally dating from the late 16th century. It was a vital link in the defence of this important waterway, the gateway to the ◄ south-east of Ireland.

The little village of Ballyhack lies in the west of the county, on the eastern bank of the Barrow estuary. A ferry plies from here across the estuary to Passage East on the Co. Waterford side. ▼

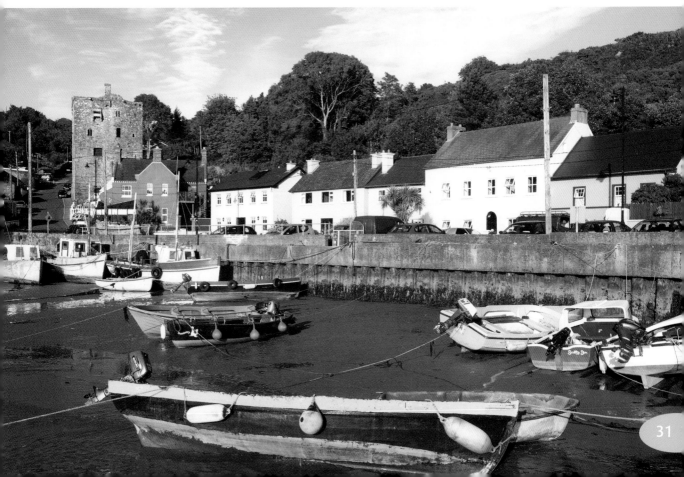

KILKENNY

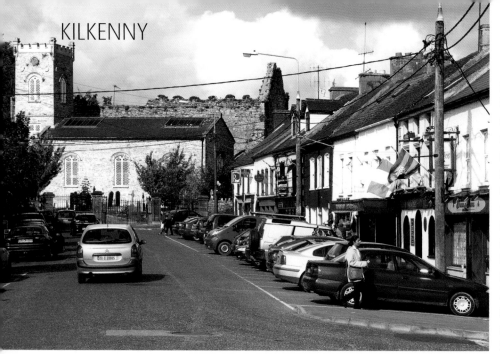

Thomastown, one of the many attractive towns on the lower reaches of the River Nore. The Nore is one of the three sisters, the rivers that drain the south-east and empty into the great estuary below Waterford. The others are the Suir and the Barrow, of which the Nore is a tributary. The Barrow is the second longest river in Ireland after the Shannon.

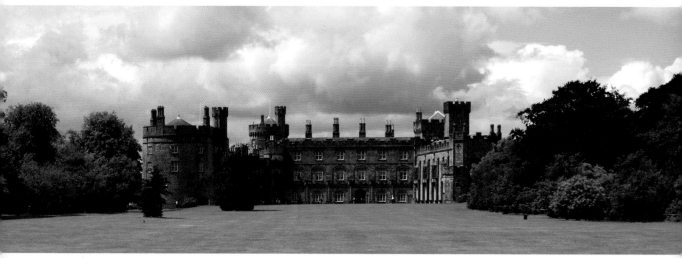

Kilkenny Castle, ▲ ancestral home to the powerful Butler family, was in the family's hands until 1967 when they gifted it to the state.

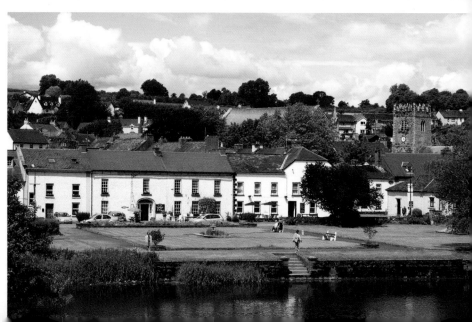

Inistioge, perhaps the prettiest of all the Nore villages.

KILKENNY

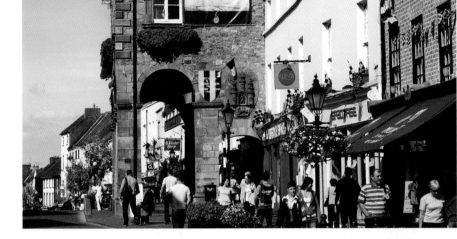

The Tholsel in the heart of Kilkenny city. A tholsel was originally a toll booth, later developing in function to become a civic centre or town hall.

St Canice's Cathedral in Kilkenny city.

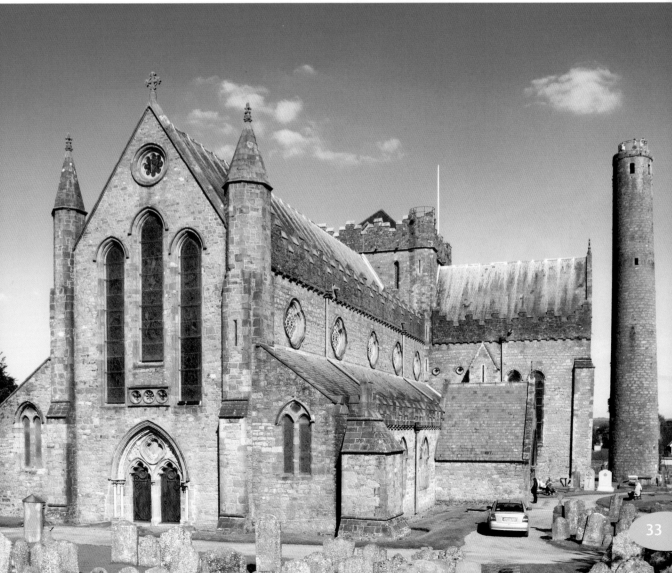

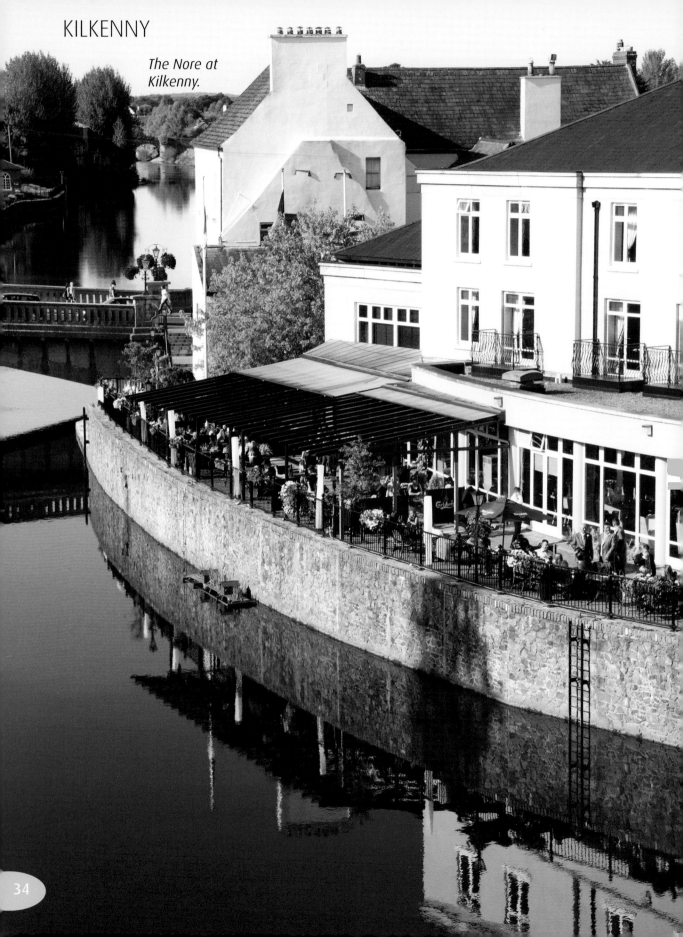

KILKENNY

The Nore at Kilkenny.

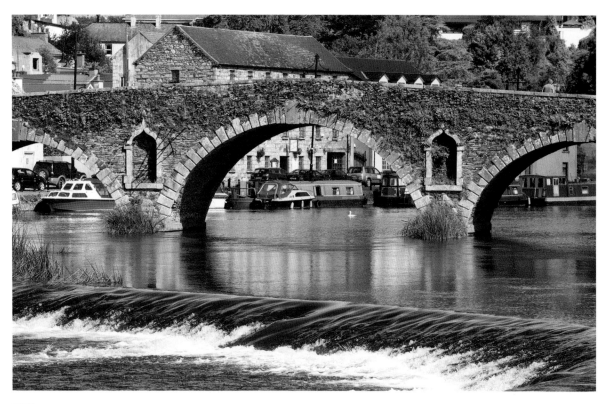

The bridge at ▲
Graiguenamanagh in
east Co. Kilkenny on the
River Barrow.

◄

Open country near
Graiguenamanagh.

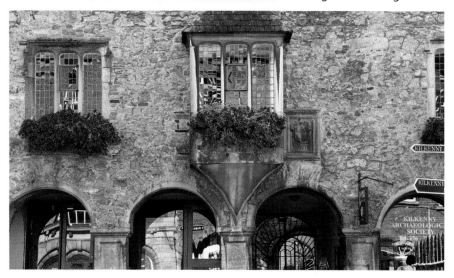

Rothe House is one of
the oldest buildings in
Kilkenny, dating from
1594. ►

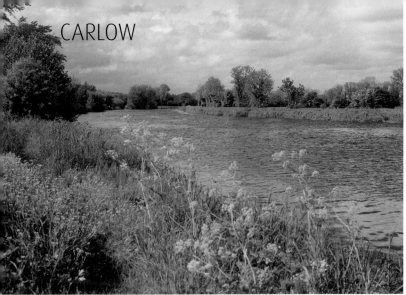

◄ The Barrow near Borris, Co. Carlow.

Bagenalstown, Co. Carlow. This is one of those Irish towns whose name was Gaelicised after independence. Some Irish-language forms have stuck; others have not. This is one that has not. Very few people refer to it as Muine Bheag, its official name. Instead, we continue to remember its founder, Lord Walter Bagenal, founder of the town and a member of one of the most distinguished Hiberno-Norman families. ▼

◄ Altamont Garden in Co. Carlow claims to be the most romantic garden and it may well be.

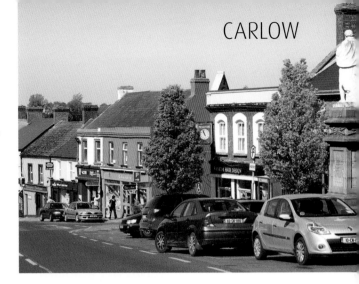

Tullow in the east ▲ of Co. Carlow.

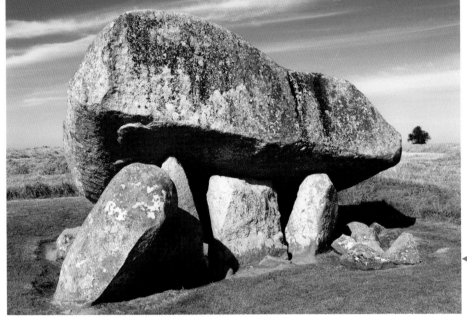

◄ The ancient dolmen at Browneshill, Co. Carlow. ▼

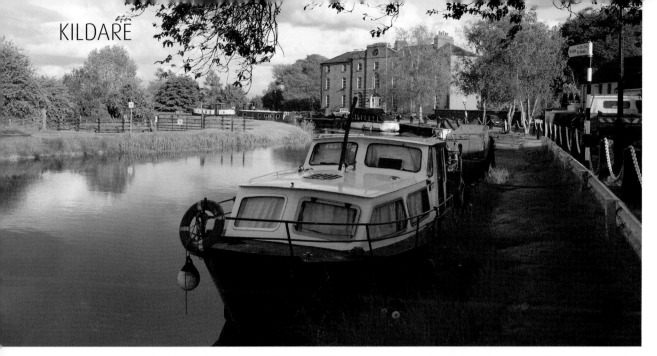

The Grand Canal at Robertstown, Co. Kildare. This was an important stopping point for traffic on the canal. The hotel to the right in the background was built in 1801. It is often forgotten that canals represented the most dramatic advance in human movement since the Roman Empire. Within 40 years of the Grand Hotel opening, canals were overwhelmed by the coming of the railway.

The Japanese Gardens at the Irish National Stud in the Co. Kildare countryside. This authentic surprise is a major attraction within easy distance of Dublin.

The early morning gallops on the Curragh, the spiritual home of Irish horse racing.

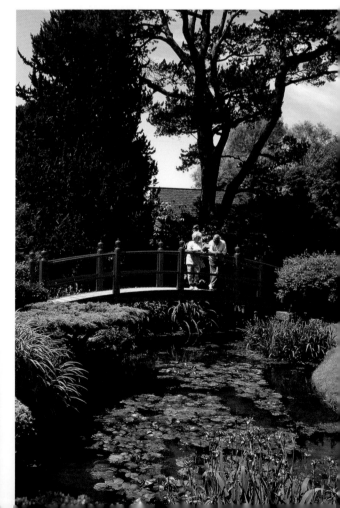

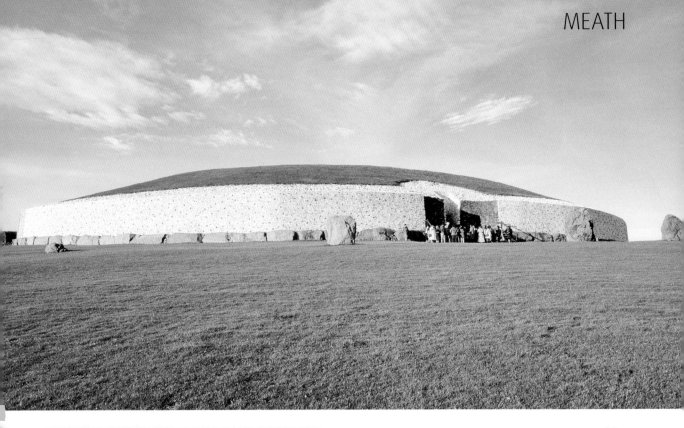

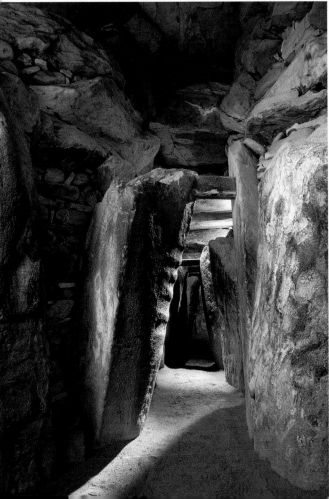

◄ *Two images of Newgrange, a 5,000-year-old* ▲
passage tomb famous for the winter solstice
when the light of the rising sun illuminates
its passage and chamber. It is one of Ireland's
greatest attractions.

The Hill of Tara, one of the largest complexes
of Celtic monuments in Europe, is bathed in
Celtic mythology. According to tradition, it was
the seat of the High King of Ireland. ▼

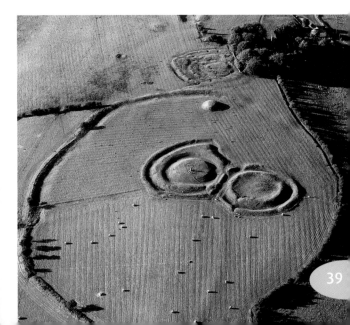

The classical centre of Birr, Co. Offaly, the planned estate town of the Earls of Rosse. Most Irish towns and villages are unplanned and random collections of buildings, but towns like Birr and Westport in Co. Mayo were the product of enlightened resident landlords.

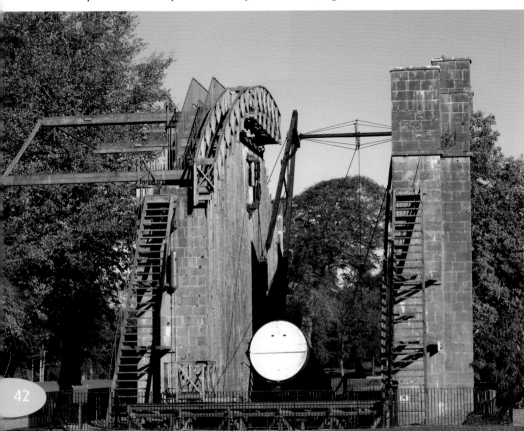

The 19th-century astronomical observatory built at Birr Castle by William Parsons, 3rd Earl of Rosse, included this telescope constructed in 1845. Until 1917, it remained the largest telescope in the world. Parsons was a gifted mathematician.

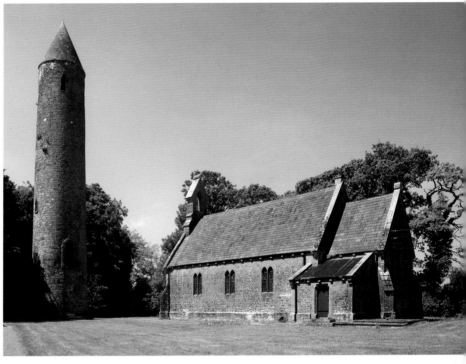

Abbeyleix, in the midland county of Laois (formerly Queen's County in honour of Queen Mary, who sponsored a 16th-century plantation there) is another estate town, this time the patrons being the Lords de Vesci. It also contains Morrissey's, one of the great Irish pubs. The far side of the room is an old-fashioned grocer's shop and there is an undertaking business out the back.

12th-century Round Tower and former Anglican parish church of Timahoe. The church, now used as a library, was designed by Joseph Welland and built c. 1840. ▶

Dunamase Castle, or the Rock of Dunamase, near Portlaoise. ▼

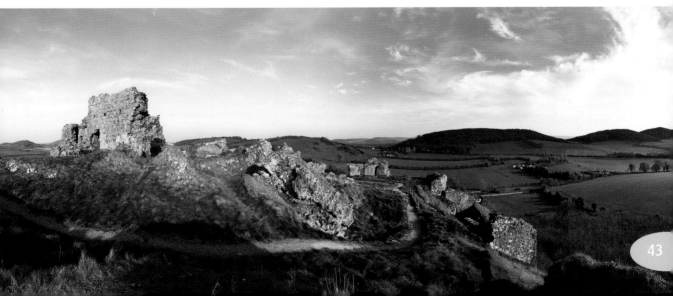

MUNSTER

Munster is the southern province. It draws more visitors, both Irish and foreign, than any other region. It is not hard to see why. The biggest province by area, it has a contrasting landscape of dramatic mountain ranges on the Atlantic coast and rich agricultural and grazing land in the central parts.

Cork is the principal city, and according to its more fevered adherents the real capital of Ireland. It has benefited from an intelligent policy of urban renewal, which was badly needed. By the mid 1980s, it was the victim of economic decline and looked like a place past its best. That was a pity and its renewal is a cause for celebration, for it is wonderfully situated beneath the steep slope of St Patrick's Hill, its centre occupying an island created by the dividing channels of the River Lee. This is the root of the Cork joke that refers to the city as the Paris of Ireland; so why isn't Paris ever called the Cork of France?

The renewal of the city was welcome for other reasons. It is a handsome place, with some fine Victorian buildings, a magnificent deep-water port and a rural hinterland that no other city in the country can match. In some ways it was an improbable site for a settlement, for although the island nature of the centre obviously offered great potential for defence against raiders, the land itself is low lying and the city is prone to flooding. Indeed, its name comes from the Irish word 'corcaigh', meaning 'swamp'.

Apparently it's not just the Paris of Ireland, but almost the Venice as well!

Cork people are passionate in their local loyalty, never more so than when their hurlers compete in the All-Ireland Championship. This ancient Irish summer game is a magnificent spectacle, involving courage, exceptional skill and incredible speed; it is reckoned to be one of the fastest field games in the world. To the uninitiated eye, it looks like mayhem. Far from it, it is a stick-and-ball game which at its best takes the breath away. And Cork is one of the great powers of the game. Their colours are red and white: the blood and bandages. When their supporters turn up, they bring any flags they can lay their hands on that have a decent quotient of red in them: Japanese naval flags, stars and stripes, stars and bars, the Soviet and Chinese flags (just to show they are not all to one side), Ferrari flags. They are the most colourful, noisy and committed supporters in Irish sport – with the possible exception of the supporters of the Munster provincial rugby team. Whether it's Cork in particular or Munster in general, the people in the south cheer for their team.

Whereas most parts of the county east of the city and in the centre boasts good agricultural land, the west is typical Atlantic coastline with mountains, deep ocean inlets, pretty towns and villages, and, one of the great successes of modern Ireland, excellent food. Ireland used to have a

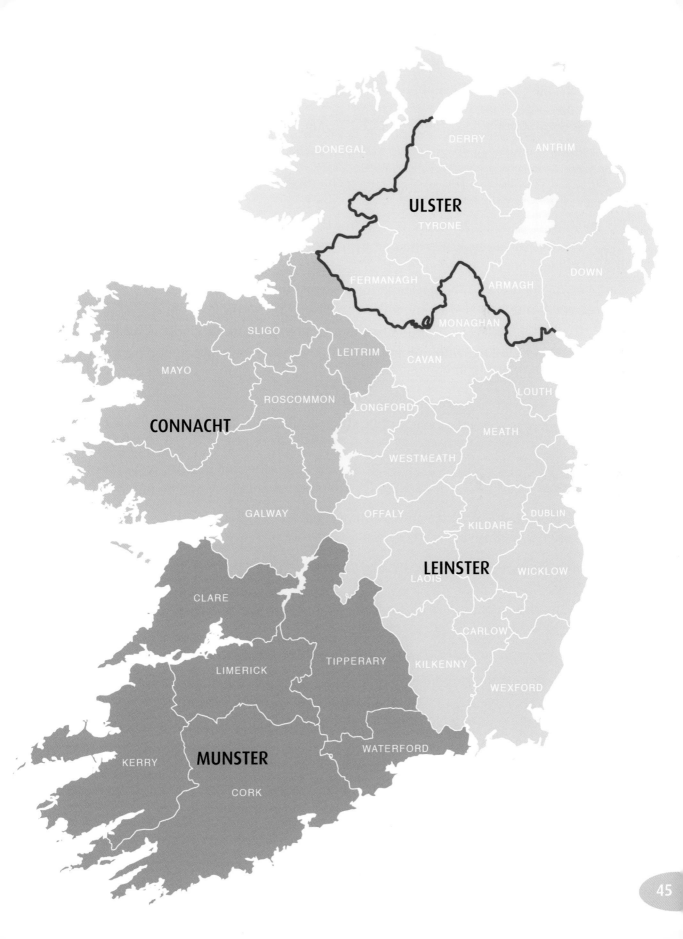

ULSTER

DONEGAL

DERRY

ANTRIM

TYRONE

DOWN

FERMANAGH

ARMAGH

MONAGHAN

SLIGO

LEITRIM

CAVAN

LOUTH

MAYO

ROSCOMMON

LONGFORD

MEATH

CONNACHT

WESTMEATH

GALWAY

OFFALY

DUBLIN

KILDARE

LEINSTER

WICKLOW

LAOIS

CLARE

CARLOW

LIMERICK

TIPPERARY

KILKENNY

WEXFORD

KERRY

MUNSTER

WATERFORD

CORK

deserved reputation for bad food. No more. In the centre of Cork city, the English Market is by a distance the best food market in Ireland; just south of the city, the coastal town of Kinsale has a fair claim to be the gastronomic capital of the country; and near the eastern town of Midleton, Ballymaloe House has been the single most famous nursery of top Irish cuisine for three generations.

Kerry is the county to the west of Cork, running all the way up to the Shannon estuary. They say there that St Patrick never got to Kerry because the Cork people stole his donkey! Kerry is the Yorkshire or Texas of Ireland, even managing to outdo Cork in this respect. In Killarney, it has the one Irish tourist attraction that trumps all others, plus three stunning peninsulas (one of which it shares with Cork) that jut into the Atlantic like long fingers and provide the backdrop for a succession of dramatic marine views. The middle one has a coastal road known as the Ring of Kerry. The most northerly of the three, the Dingle Peninsula, is arguably the finest of all. At its end, you are at the most westerly point in Ireland with nothing but water between you and somewhere to the north of Newfoundland.

And that in turn tells you something about Ireland and, indeed, about north-west Europe in general. It is very, very far from the equator, 52° to 55° north. In the southern hemisphere, only the very tip of South America and the Falkland Islands lie at a similar latitude. Were it not for the warm-water current called the Gulf Stream, which starts in the Caribbean and flows right past the island, much of Ireland would be tundra.

North of Kerry, across the Shannon estuary, is Co. Clare. If it's Irish music you want, this is the county to visit. Also, the dramatic Cliffs of Moher should on no account be missed.

The other three Munster counties are Limerick (next to Clare), Waterford in the far south-east of the province, and Tipperary in the middle – the only one of them that is landlocked. Limerick is sited just where the Shannon begins to billow out into its estuary. It has one of the finest Hiberno-Norman strongholds in the country in King John's Castle. The pretty thatched village of Adare is only about ten miles away.

Tipperary is fertile agricultural country whose principal topographical feature is the magnificent Rock of Cashel, which stands proud like a sentinel over the flat country all around. Originally a stronghold of the ancient Munster kings, it was later an ecclesiastical site and to this day Cashel is an archepiscopal seat. Waterford is a small city of Viking origin at the headwaters of a superb three-river estuary. Its most iconic surviving building, Reginald's Tower, is more than a thousand years old and the oldest surviving building anywhere in Ireland to be constructed using mortared stone.

Ross Castle on Lough Leane near Killarney. ▶

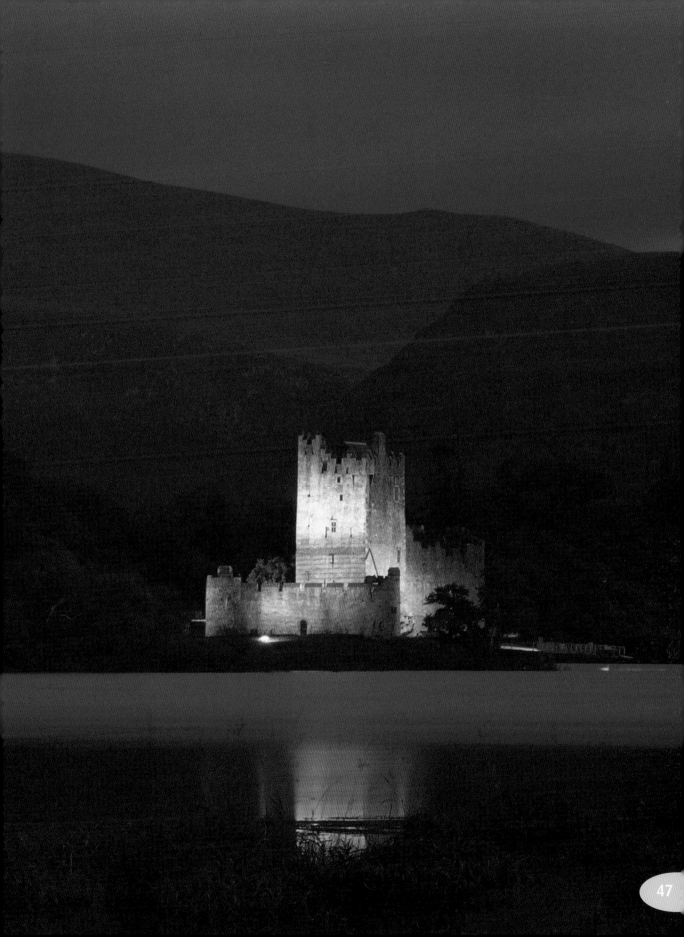

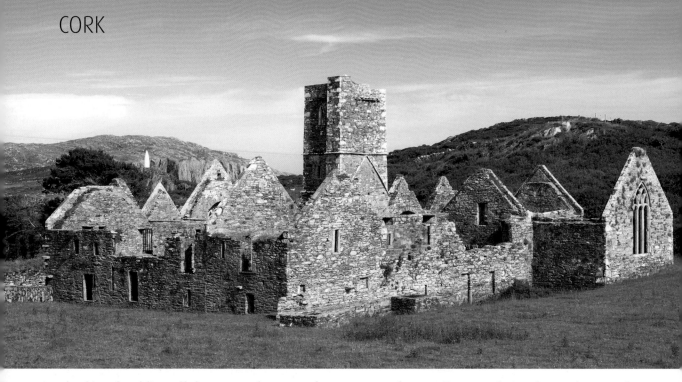

▲ Sherkin Island lies off the coast of West Cork near the pretty town of Baltimore. The photograph shows the ruins of the old 15th-century Franciscan friary, usually (if erroneously) called Sherkin Abbey. The island supports a small indigenous population and is a popular holiday destination.

The small town of Kinsale, at the mouth of the River Bandon just south of Cork city, has a fair claim to be the capital of Irish gastronomy. It boasts a large number of excellent restaurants and is also a popular sailing venue. ▼

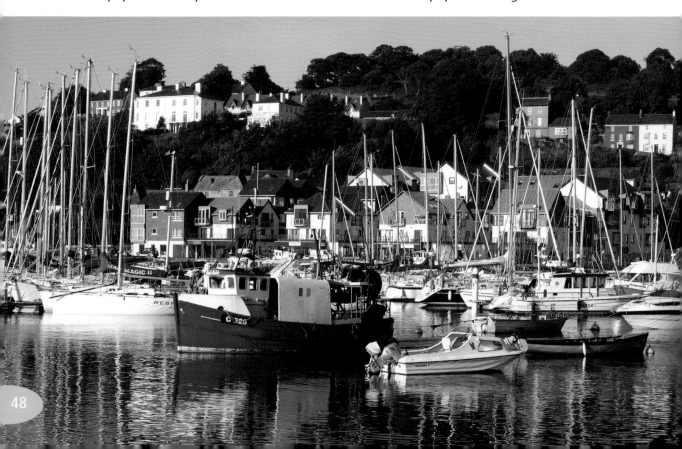

Desmond Castle in Kinsale is an old tower ▶
house built in the days when all of south
Munster was controlled by the southern
branch of the Fitzgerald family, the mightiest
of the Hiberno-Norman magnates. Desmond
is simply the Anglicisation of the Gaelic words
for south Munster (Deas Mumhan). The power
of the Fitzgeralds of Desmond was finally
broken by the English crown in the pitiless
wars of the 1570s and 1580s. In 1601, a
Spanish fleet sailed here in support of the last
great Gaelic rebellion against English rule,
but to no effect. Thereafter, Kinsale and much
of the surrounding country was an English
redoubt for centuries.

Cobh Cathedral, dramatically situated above
the principal town in Cork harbour. The
cathedral, named for St Colman, was designed
by E.W. Pugin, son of the famous Augustus
Welby Pugin, the greatest of all Victorian Gothic
architects. Begun in 1868, it was not complete
until 1917, although further embellishments
continued until after World War II. ▼

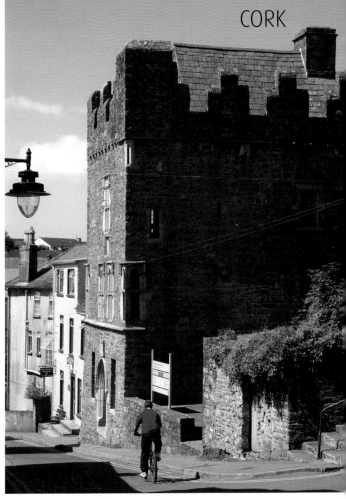

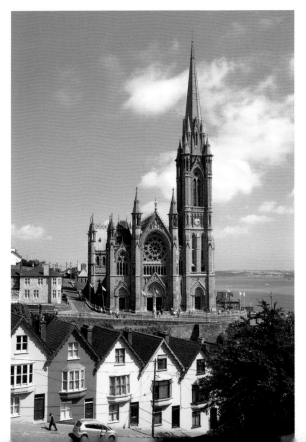

The River Bandon on its
approach to Kinsale. ▼

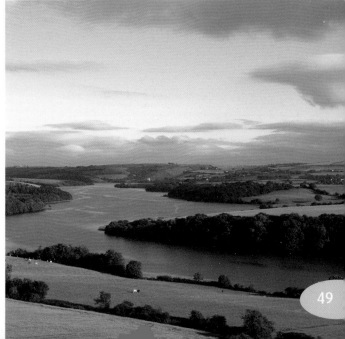

CORK

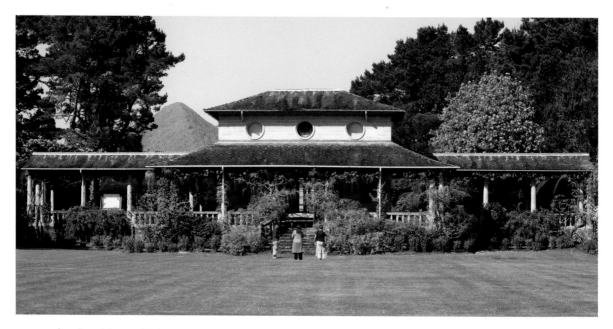

Garinish Island lies off the coast near Glengarriff on the north shore of Bantry Bay. The area has a particularly mild climate, which supports flora that could not otherwise thrive in these latitudes. In the early years of the 20th century, the owner of the island, John Allen Bryce, had this ornamental Italian garden laid out. It is now in the care of the state. ▲

The quay at Cobh. It was from here that the Titanic sailed for the last time on her fatal maiden voyage. ▼

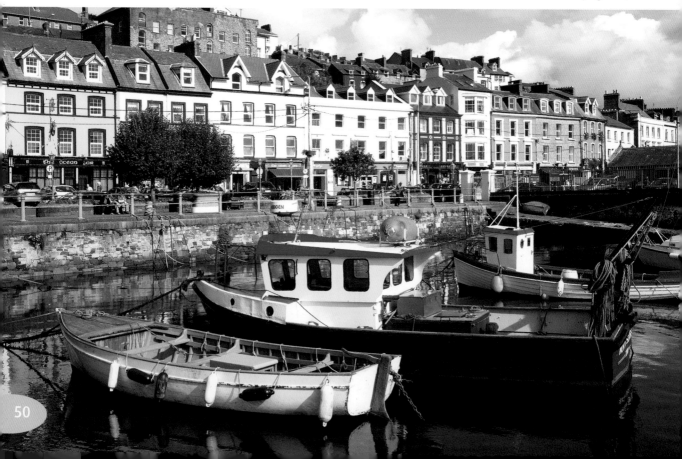

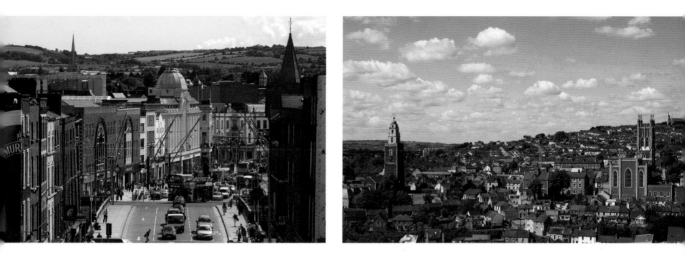

Two views of Cork, the principal city of Munster, showing the rising ground on the north side containing the celebrated bell tower of Shandon church on the left (above right) and Patrick Street (above left), the principal shopping street in the city centre.

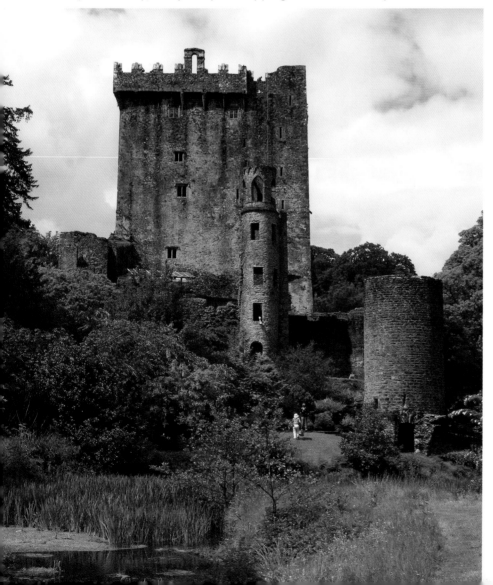

Blarney Castle was built in 1446 as a stronghold of the McCarthys. It has become famous for its Blarney Stone, of which it is said that if you kiss it you will be rewarded with the gift of eloquence. This is a fairly recent myth, concocted as mass tourism developed in the 19th century, but it's a bit of fun!

51

CORK

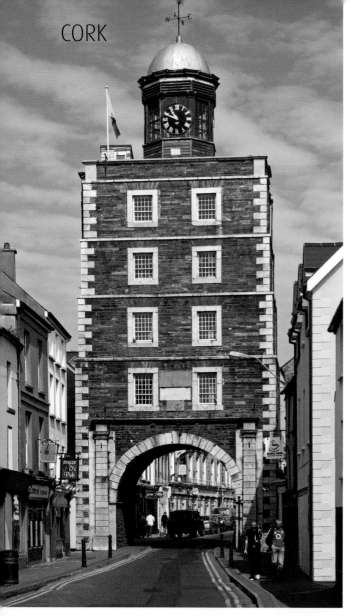

The Clockgate Tower in the pleasant and historic town of Youghal in east Cork, which stands on the estuary of the Blackwater River. The town was founded by the Hiberno-Normans in the 13th century and was briefly the property of Sir Walter Raleigh at the end of the 16th. However, Raleigh sold it to Richard Boyle, the Great Earl of Cork – a classic new Englishman on the make in Ireland. The clock tower dates from 1777.

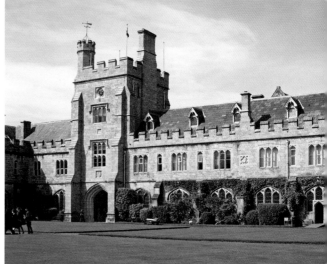

University College Cork, the principal university of the region. Founded as one of the Queen's Colleges in 1845, it became a constituent college of the National University of Ireland in 1908.

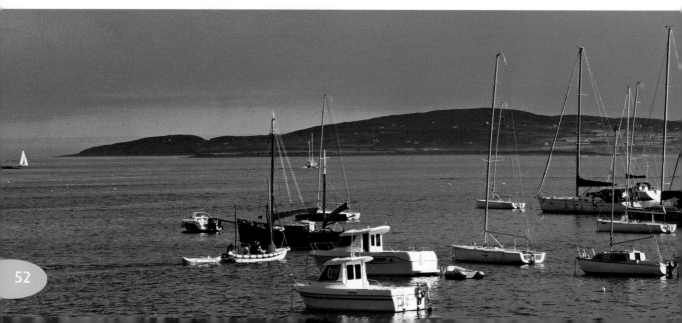

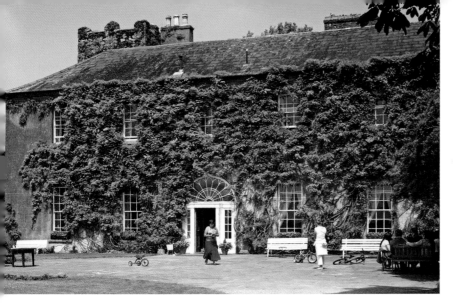

Ballymaloe House in east Co. Cork is probably the single most celebrated restaurant and cookery school in Ireland. The property of three generations of the Allen family, it has not only maintained an outstanding restaurant, but its school has trained most of Ireland's distinguished chefs.

Baltimore, one of the many delightful towns in West Cork. In 1631, pirates from as far away as Algeria sailed here in their corsairs and carried over 200 of the locals away to slavery. Things are a little less stressed these days. ▶

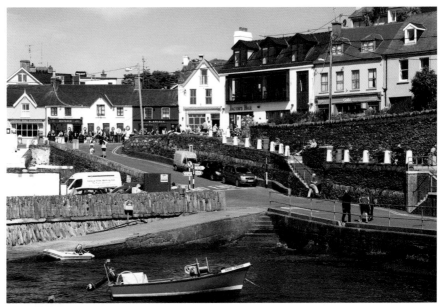

The harbour at Schull in West Cork. ▼

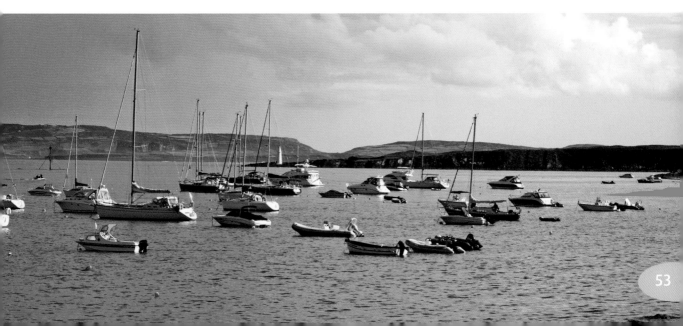

CORK

Timoleague is a small town to the west of Cork city on the way to Clonakilty and Skibbereen. It contains these Franciscan friary ruins of a foundation originally dated to 1240.

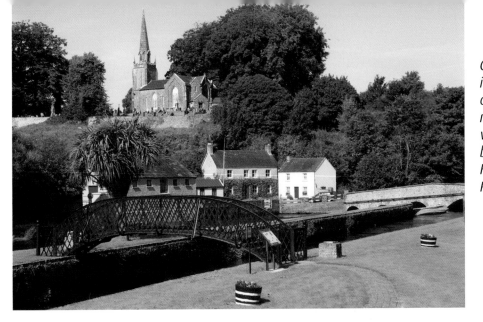

Castletownroche in the north of the county was, as the name suggests, a village originally built by the Hiberno-Norman Roche family.

Midleton in the east of Cork is now the principal centre of the Irish distilling industry. This photograph shows the Jameson distillery at Midleton. Formerly, Jameson whiskey was distilled in Dublin. ▶

Macroom, in the north-west of the county, is an important market town. Macroom Castle, shown here, was one of the strongholds of the McCarthys. Under the Cromwellian confiscations, the McCarthys were dispossessed and the castle passed into the hands of William Penn, whose son and namesake went on to found Pennsylvania. ▼

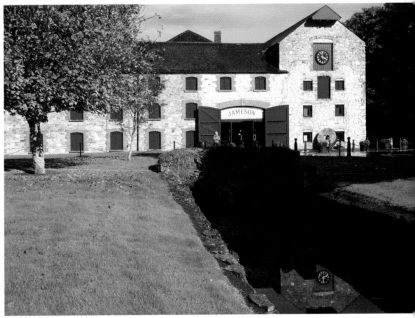

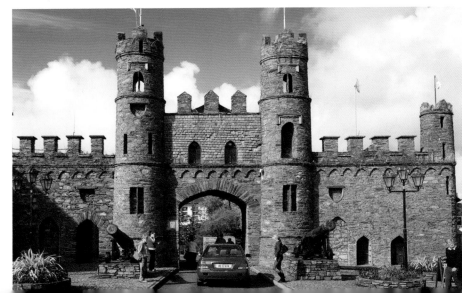

◀ Mizen Head in West Cork, the most southerly point in Ireland.

The entrance to the English Market in the ▲ centre of Cork, beyond all question the finest food market in Ireland.

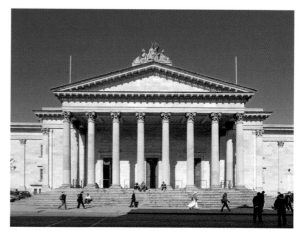

Cork City court house in Washington Street. ▲

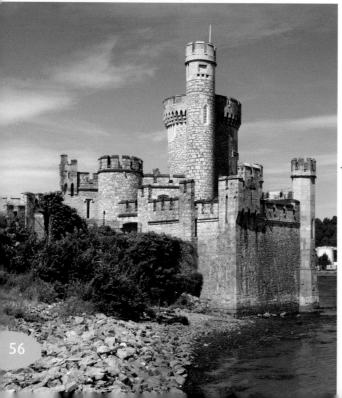

◀ Blackrock Castle is situated on a strategic site just downriver from Cork city centre at a point where it can defend the city approaches from the sea. This was the function of the first two structures on this site, the oldest of them dating to 1582. The present castle dates from 1829. For many years it was in private ownership, but is now in the ownership of Cork City Council. There is an observatory here operated by the staff of Cork Institute of Technology.

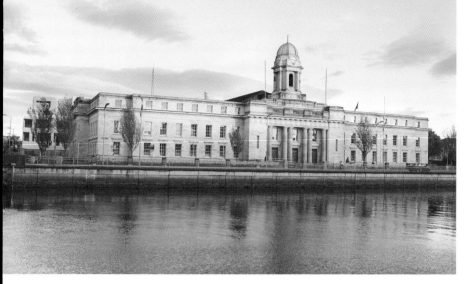

Cork City Hall sits at the junction of Anglesea Street and Terence MacSwiney Quay. MacSwiney was a mayor of Cork during the War of Independence, who died on hunger strike in a London prison after a 74-day ordeal. He is regarded as one of the martyrs of the Irish freedom movement.

St Fin Barre's Cathedral in Cork is one of the city's great landmarks. Designed by a London architect, William Burges, its neo-Gothic style is delivered with great exuberance. It serves the faithful of the Church of Ireland diocese of Cork, Cloyne and Ross.

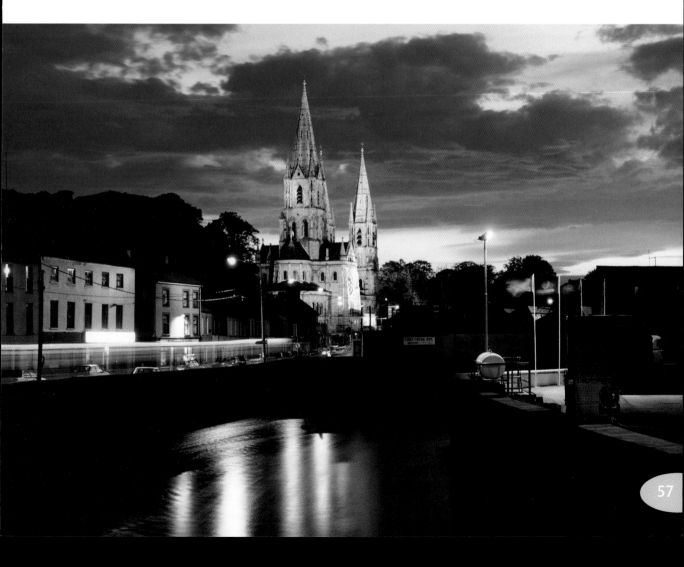

▲ At the far north-eastern diagonal corner of the Iveragh Peninsula stands the town of Killorglin. The river is the Laune. From 10–12 August each year, Killorglin is home to Puck Fair, an ancient gathering presided over by a white male goat which is captured in the nearby mountains and hoisted aloft in a basket, there to preside over three days of trading and revelry.

Derrynane House at Caherdaniel at the south-west corner of the Iveragh Peninsula in Co. Kerry. This was the home of Daniel O'Connell, the Liberator, one of Ireland's greatest men. The O'Connells were minor Gaelic aristocrats, who maintained a discreet life for many generations through smuggling and other activities for which this remote location was ideal. O'Connell himself (1775–1847) was one of the finest lawyers and parliamentarians of his time. ▼

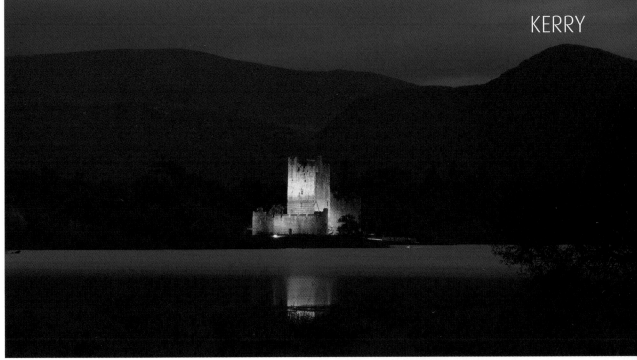

Ross Castle on Lough Leane near Killarney. ▲
*The original castle was built in the 16th
century by the O'Donoghues, but in due time
it passed into the hands of the Anglo-Irish
Browne family, who held it until recent times.*

Ladies View, looking back on the Lakes of ▶
*Killarney from an elevated viewing point on
the road to Kenmare.*

Sunset on Kenmare Bay. ▼

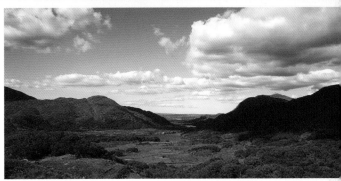

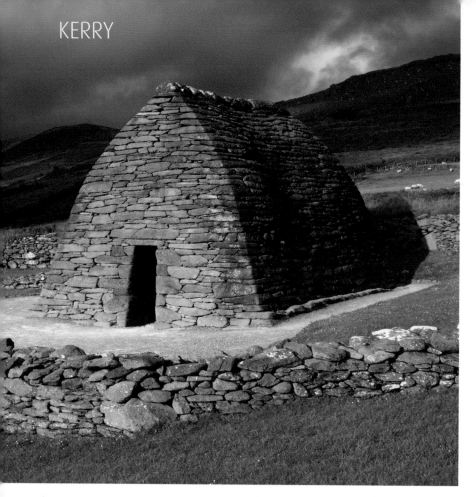

At the western end of the Dingle Peninsula, near the village of Ballyferriter, stands this remarkable little oratory at Gallarus. It is constructed almost entirely of unmortared stones, which were shaped and overlaid one upon the other to give it the appearance of an upturned boat. However, despite the absence of mortar and the fact that it has survived for a millennium or more, it is as dry as a bone inside – even in one of the wettest climates in Europe!

The harbour at Derrynane with the Great and Little Skelligs on the horizon.

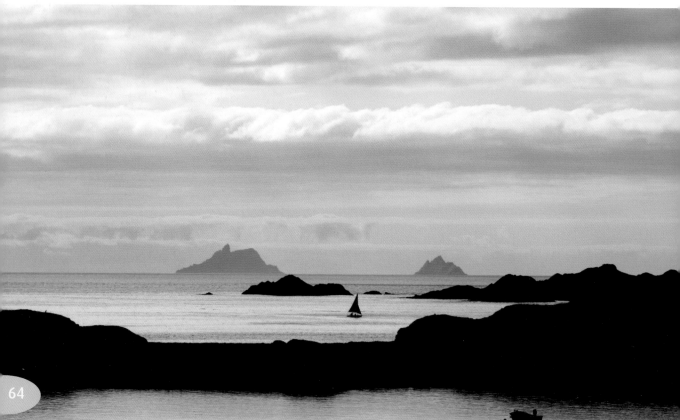

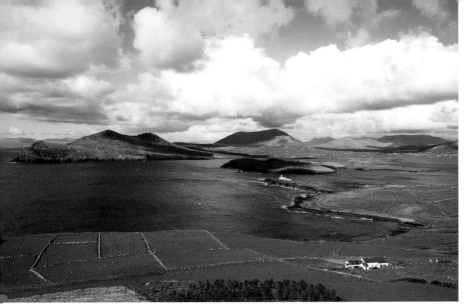

Valentia Island lies just off the end of Iveragh. This view looks back from the island to the mainland.

Ireland has many ▶ magnificent beaches, and this one at Inch, Co. Kerry – a sandy spit on the south coast of Dingle Bay – could claim to be the finest of the lot.

At the county border between Kerry and Cork, in the Slieve Miskish Mountains, the road runs through the Healy Pass, the foot of which is shown here. The pass is named for Timothy Healy, Irish nationalist politician and first governor-general of the Irish Free State following independence. ▼

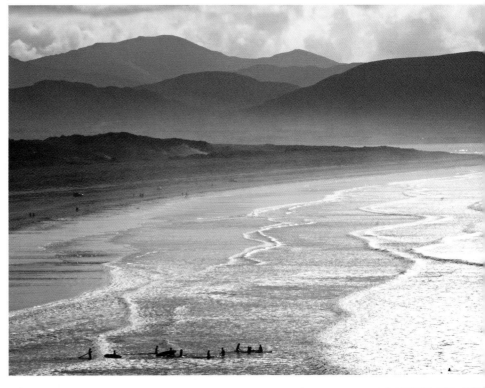

KERRY

The Atlantic coast in turbulent mood west of Dingle.

The beach at Rossbeigh, with the ▶
mountains of the Dingle Peninsula in the
background. Rossbeigh beach is another
sandy spit jutting into Dingle Bay, almost
opposite Inch on the far side.

Kenmare Bay in the evening light near the
pretty village of Sneem. ▼

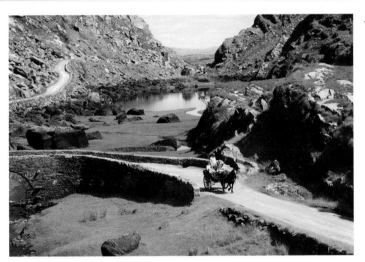

◀ The Gap of Dunloe, one of the
most picturesque spots in the
Killarney region.

The beach at the little village of
Ballyferriter in the Kerry Gaeltacht,
west of Dingle. The mountains in
the background are known as the
Seven Sisters, although only two of
▼ them are visible in this photograph.

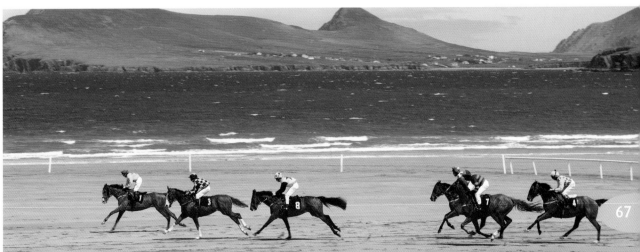

67

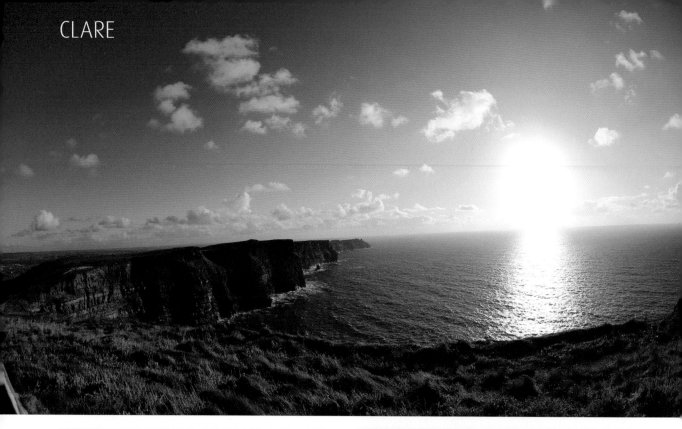

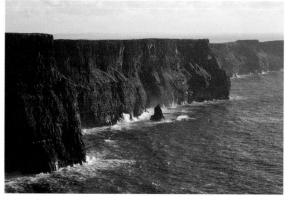

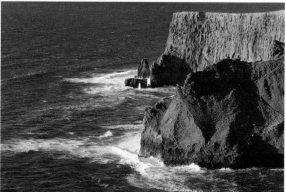

Four views of the Cliffs of Moher on the west coast of Clare. These are the highest cliffs in Ireland.

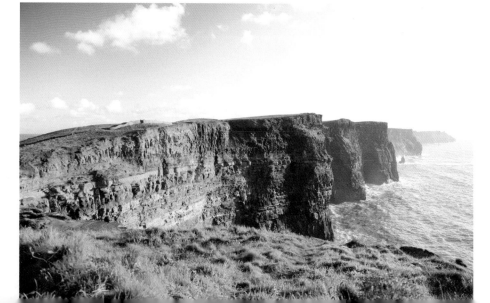

Bunratty Castle is a wonderful example of a restored 15th century tower house. ▶

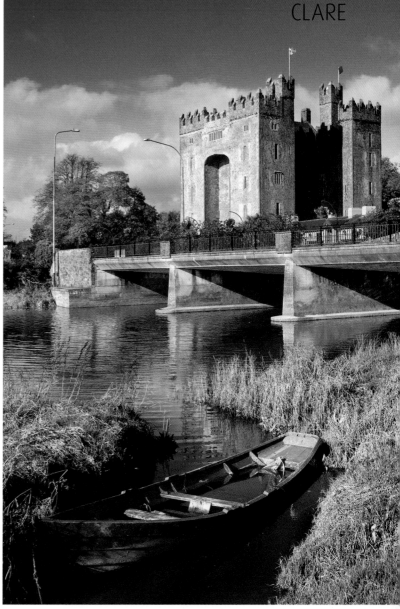

The Burren is an extraordinary landscape of karst rock in north-west Co. Clare. The limestone covering creates channels in which plants and flora more typical of the Mediterranean and the Alps can be sheltered and can flourish. ▼

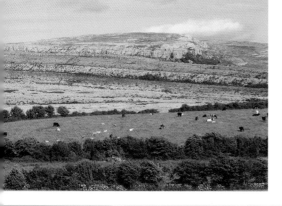

CLARE

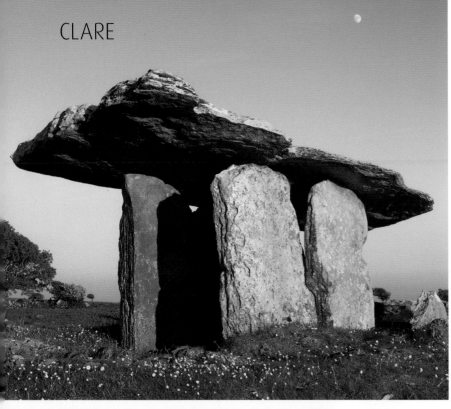

Poulnabrone Dolmen rises from the Burren landscape in a memorable way and is one of the most recognisable of Ireland's ancient monuments. It is a portal tomb and has been dated to about 3,000 BC, possibly even earlier.

A close-up of Alpine flora in the Burren. ▼

The Burren coast, near ▲ Fanore, Co. Clare.

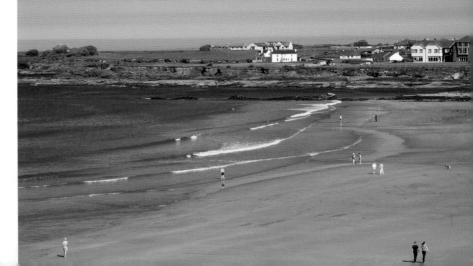

Spanish Point is a ▶ popular resort on the west Clare coast.

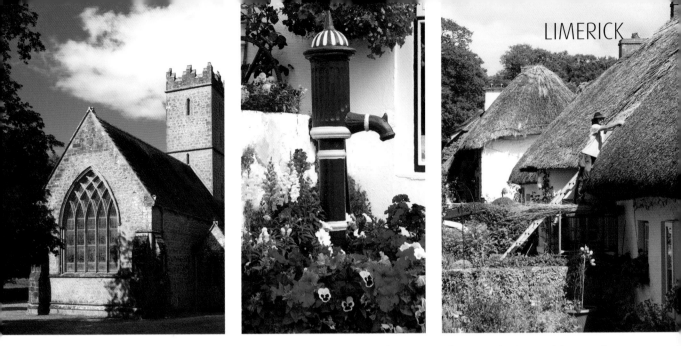

The picturesque village of Adare. The village is just 10 miles west of Limerick city and is popular both as a destination in itself and as a stopping-off point for people en route to Kerry.

The city of Limerick stands at the navigable head of the Shannon estuary. It was originally founded by the Vikings in the 9th century and subsequently fortified by the Normans. The photograph shows the principal Norman stronghold, King John's Castle, guarding the approaches to the city. The photograph on the right shows the front of the Hunt Museum, housed in the city's old custom house. ▼

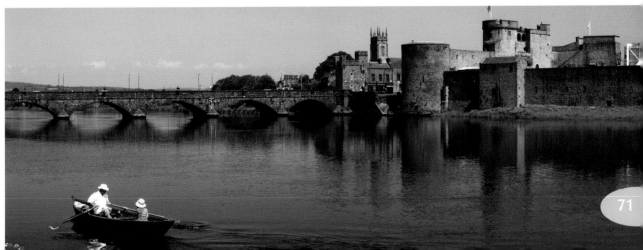

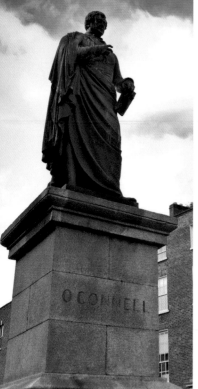

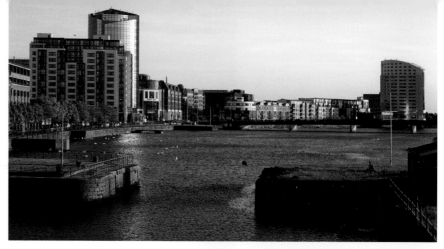

Old and new in ▲
Limerick city.

◄

The principal street in
Limerick is named for Daniel
O'Connell, whose statue –
shown here – stands near
the southern end.

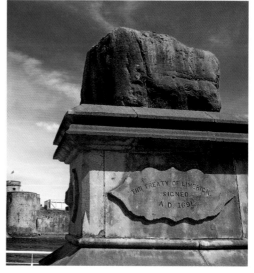

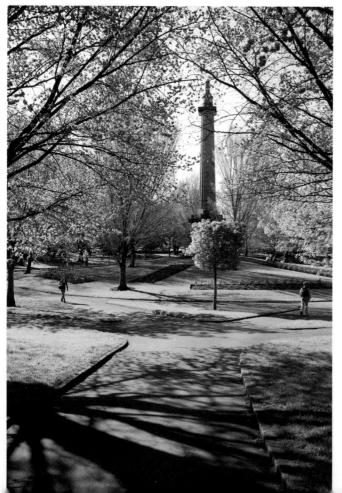

The Treaty Stone in Limerick ▲
commemorates the broken treaty
signed here in 1691 by the victorious
forces of King William III of England,
who had defeated the troops of the
deposed King James II. James had the
support of most Irish Catholics. The
terms of the treaty were not harsh and
for this reason they were not honoured
by the Irish parliament, from which
Catholics were excluded. The new
Protestant settler class wanted much
tougher terms for the vanquished.

◄

The People's Park in Limerick. The
column in the distance holds the statue
of Thomas Spring Rice aloft, a 19th-
century politician.

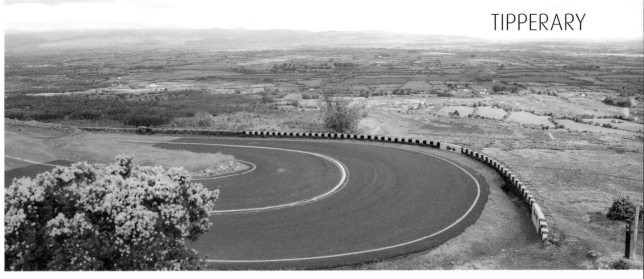

▲ *The Vee is a sharp turn in the road through the Knockmealdown Mountains in south-east Co. Tipperary, near the county border with Waterford. From here you get splendid views of the Golden Vale, the rich pastoral land in the heart of Tipperary.*

Cahir Castle was a stronghold of the Butlers of Ormond, the greatest family in late medieval Ireland. Although taken by the Earl of Essex in 1599 and by Cromwell in 1650, it managed to remain in Butler hands through all the ▼ *vicissitudes of those turbulent times.*

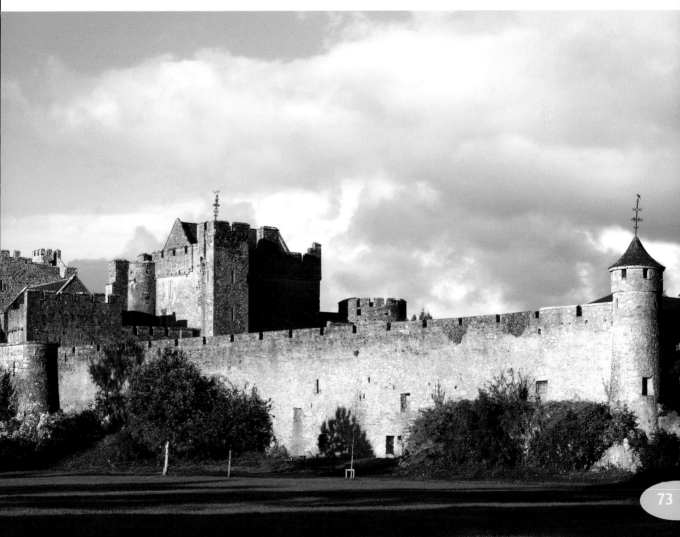

TIPPERARY

Three views of the Rock of Cashel. This dramatic promontory stands proud above the plains of Tipperary. As a naturally defensible position, it was originally the seat of the Gaelic kings of Munster and later an ecclesiastical site. There was a cathedral here, as well as a round tower that is still extant. The most interesting building in the complex is the 12th-century Cormac's Chapel, the finest example of early Romanesque architecture in Ireland. It illustrates how remote Ireland was in contemporary European terms, as the Romanesque style had prevailed on the continent for centuries before Cormac's Chapel was built.

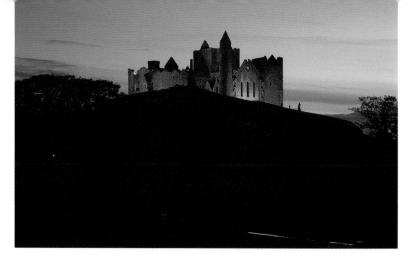

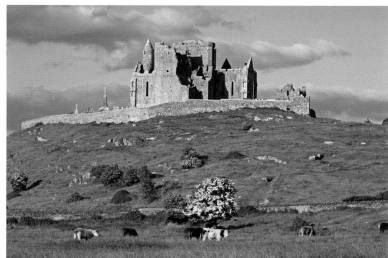

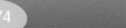

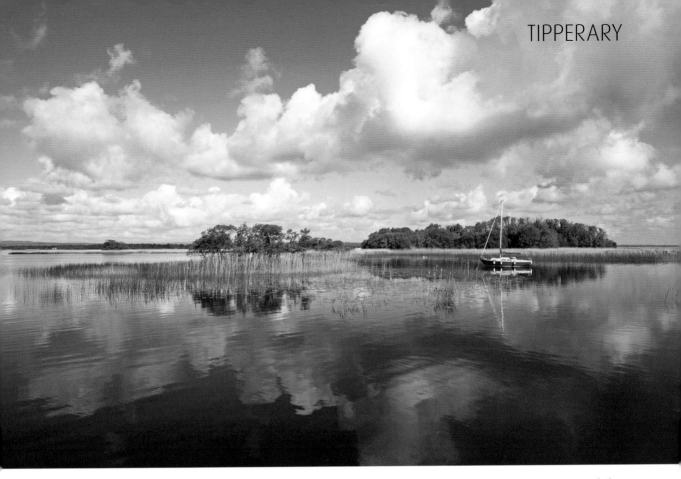

Lough Derg is the largest of the ▲
Shannon lakes and occupies
the lower reaches of the river
between counties Tipperary
and Clare.

Clonmel is an attractive and
prosperous market town
in south-east Tipperary.
Standing on the borders of
lands contested by the Earls
of Desmond and Ormond, it
eventually came under the rule
of Ormond following the Battle
of Affane in 1565. Fought to
the south of the town, it was
the last significant battle in
Irish history between two rival
magnate armies. Laurence
Sterne, author of Tristram
Shandy, once described as
the finest shaggy-dog story in
English literature, was born in
the town.

WATERFORD

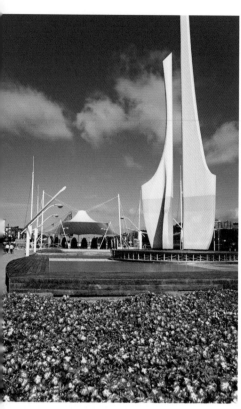

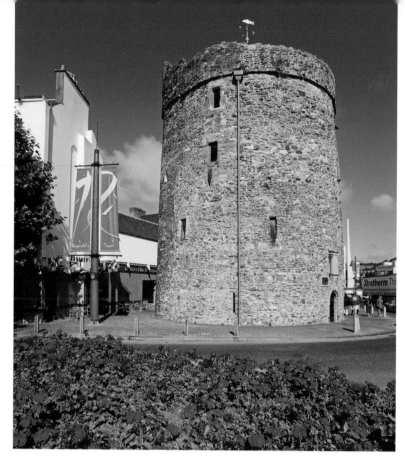

The Millennium ▲
Plaza in the centre
of Waterford.

Waterford at dusk
from the river. ▼

Reginald's Tower in Waterford city is the oldest surviving civic building in Ireland. It may be of Viking construction dating from around AD 1000, although there is some evidence that it is a later Norman addition to the town's defences. It stands at the south-east corner of the medieval walled town, guarding the estuary approach. Waterford Harbour is a magnificent deep-water estuary formed by the confluence of the three sister rivers of the south-east: the Barrow, Nore and Suir.

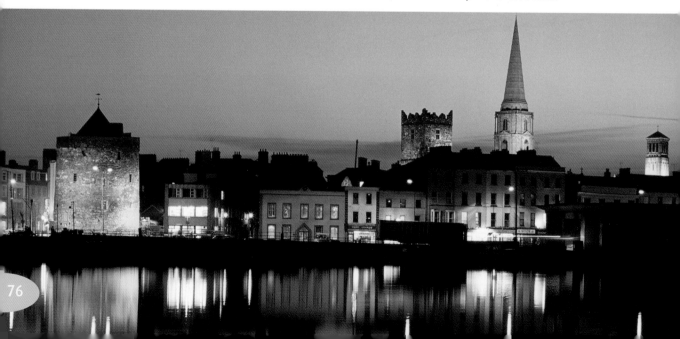

The ecclesiastical site at Ardmore, Co. Waterford, dates from the very earliest Christian era and may even pre-date St Patrick – whom many scholars suspect was not the first Christian evangelist in Ireland. If the site is early, its most famous structure, the round tower, is relatively late, dating from the 12th century. It is one of the best preserved of its kind in Ireland.

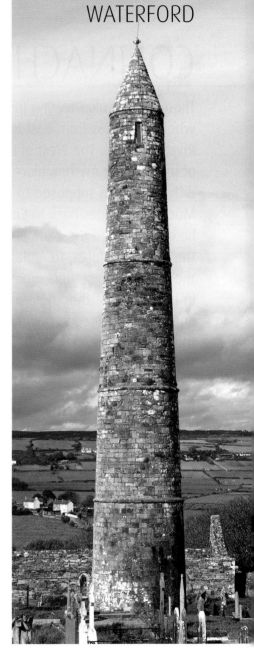

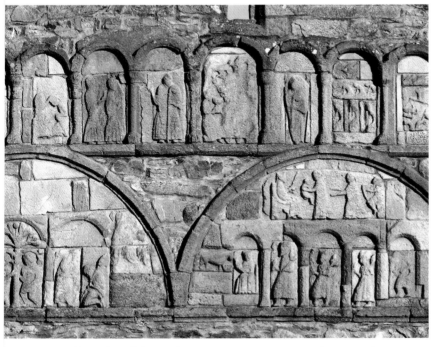

Lapidary detail from the surviving ruins at Ardmore. ▲

Dungarvan is the principal town in the west of Co. Waterford. There was an early English castle here, around which the town developed. The remains of the castle were incorporated in a 19th-century British Army barracks, which was destroyed during the War of Independence in 1921.

GALWAY

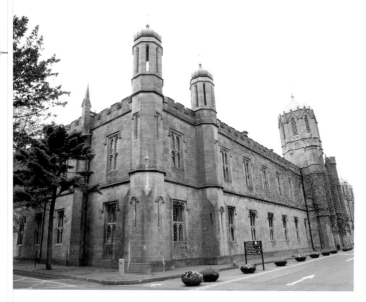

National University of Ireland Galway. Founded in 1845 as Queen's College Galway, it later became a constituent college of the National University when that body was incorporated in 1908. For many years it was simply known as University College Galway (UCG) but it adopted its current name in 1997. ◄

Shop Street, the central thoroughfare in Galway city. ►

Sunrise over the Twelve Bens in Connemara. ▼

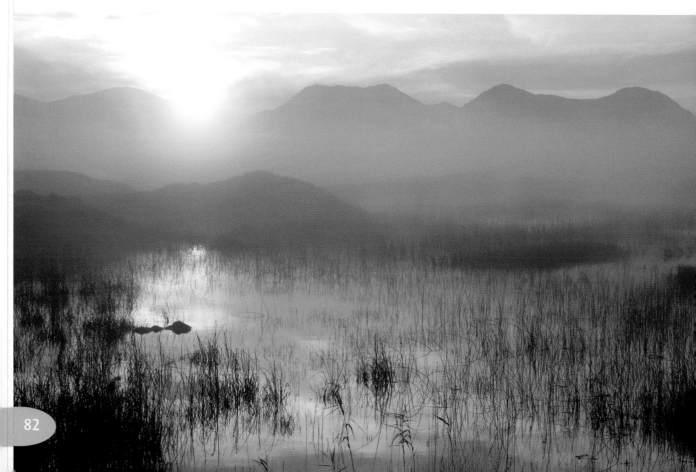

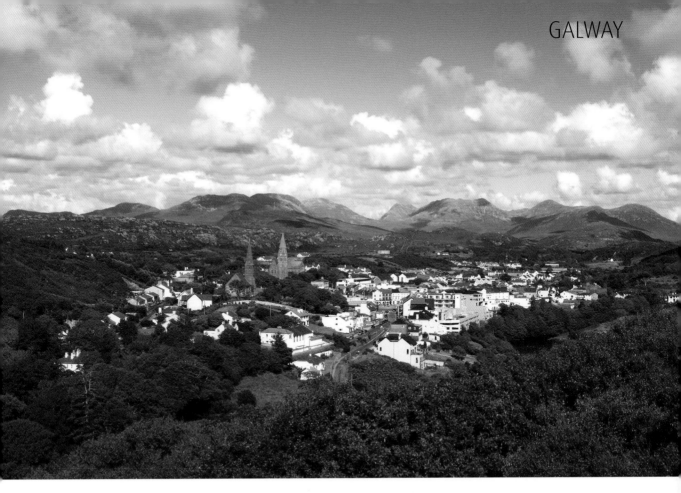

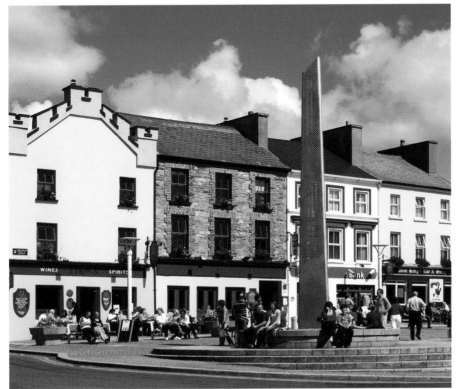

Clifden on Galway's Atlantic coast was developed as an estate town in the early 19th century by the D'Arcy family, who lived in a nearby castle. It developed steadily but suffered badly during the Great Famine. Its recovery was helped by improvements in transport communication and it is now a popular tourist resort and the self-styled 'capital of Connemara'.

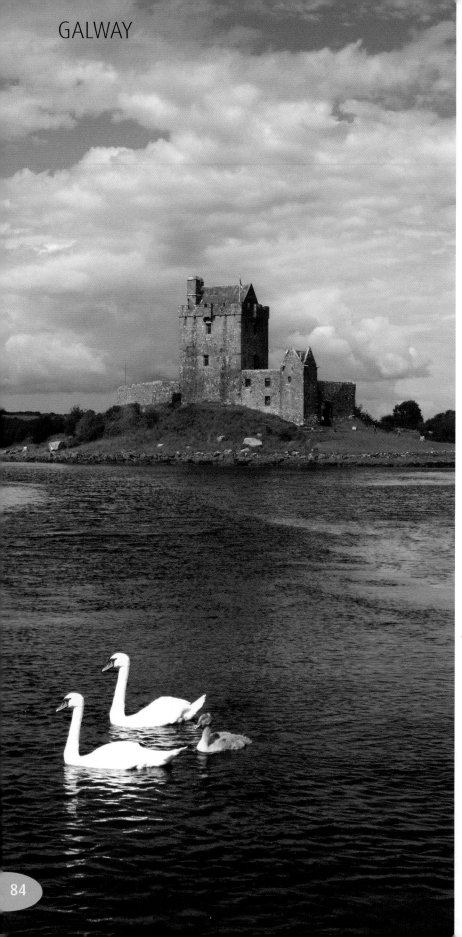

Kylemore Abbey, near Letterfrack in the west of the county, was built in the late 1860s as a family home for Mitchell Henry, a wealthy English textile merchant. Designed in a lavish Victorian Gothic style, it contains more than 70 rooms. In the 1920s it was sold to the Benedictine order of nuns, who still maintain it.

◀ Dunguaire Castle, near Kinvara at the south-east corner of Galway Bay. Although heavily restored, it is still one of the finest examples of an Irish tower house. These were domestic dwellings built all over Ireland for defence against attackers from the 15th to the 17th centuries. Those were turbulent times. Until more settled times arrived, unfortified houses carried too much risk.

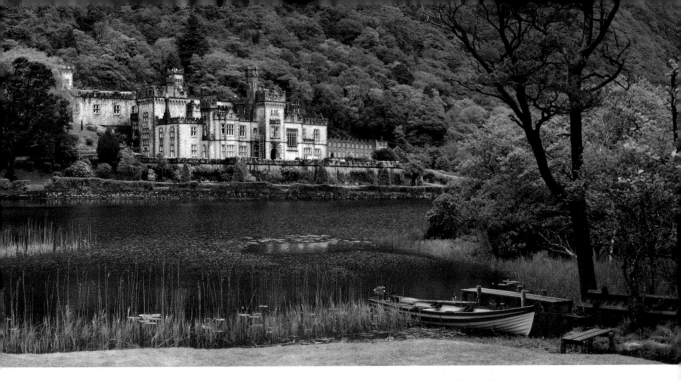

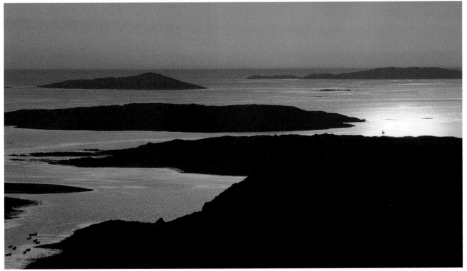

Coastal islands near Clifden.

Lough Corrib at Oughterard, a town on the Galway–Clifden road. Lough Corrib is the most southerly of the big west of Ireland fishing lakes, the others being immediately to the north across the county border in Mayo.

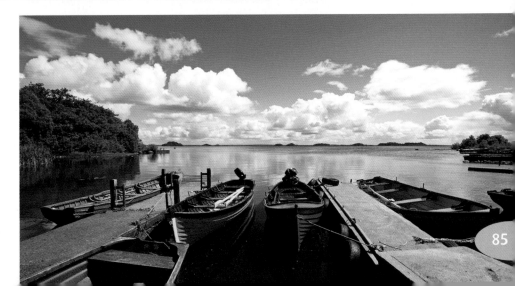

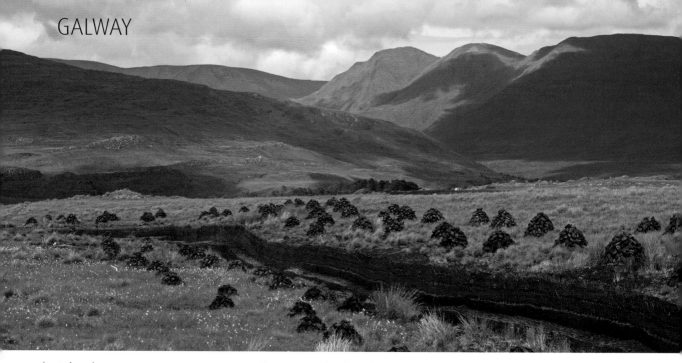

▲ Inland scene near Leenane, a small town at the head of Killary Harbour. Killary is a deep Atlantic inlet that marks the county boundary between Galway and Mayo. It can claim to be the only genuine fjord in Ireland. It was used by the Royal Navy in British days, when it was claimed that the entire fleet could be moored in Killary – this at the very apogee of British naval might.

Dun Aonghasa is a prehistoric stone fort perched dramatically on the cliff edge at the northern end of Inishmore, the largest of the three Aran Islands in Galway Bay. ▼

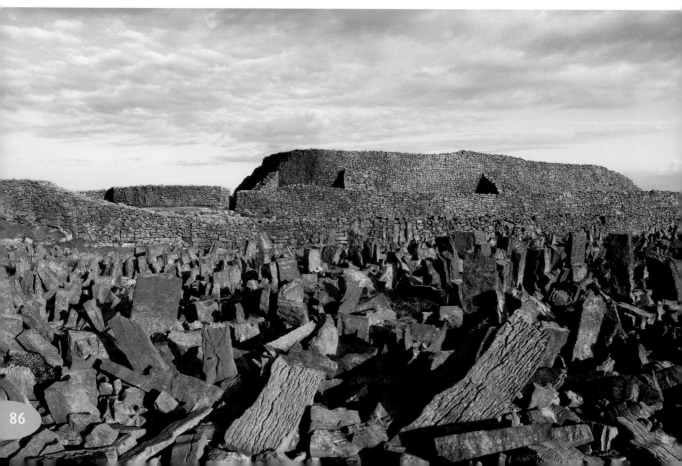

Eyre Square in the centre of Galway.

The coast near Killary Harbour.

Clifden Castle, home of the D'Arcy family, who founded the town of Clifden. ▼

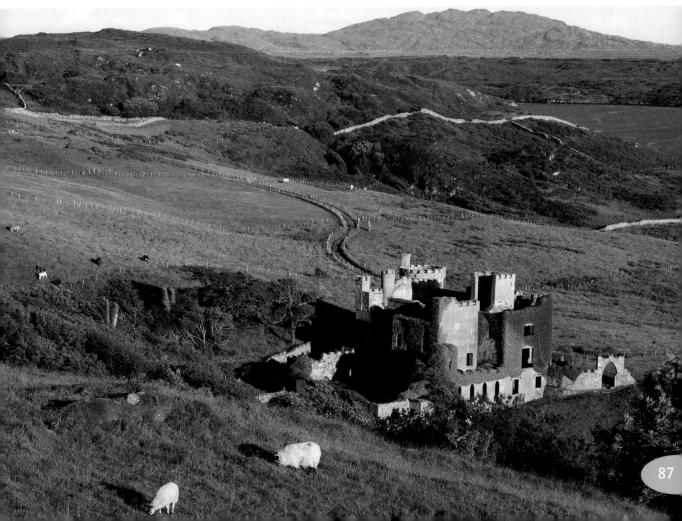

GALWAY

Kilronan is the principal town on Inishmore. ◄

The Connemara landscape near Clifden with the Twelve Bens in the distance. ▼

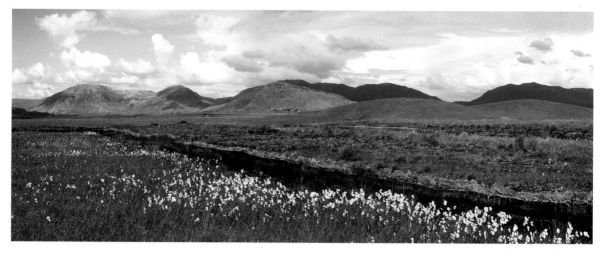

Roundstone, on ► the shores of Ballyconneely Bay.

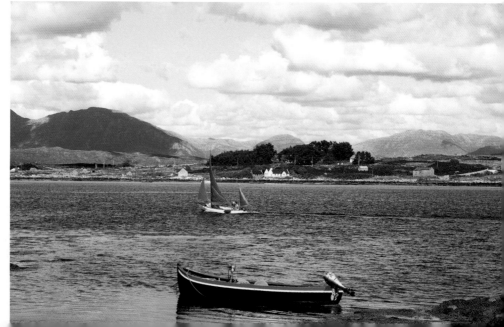

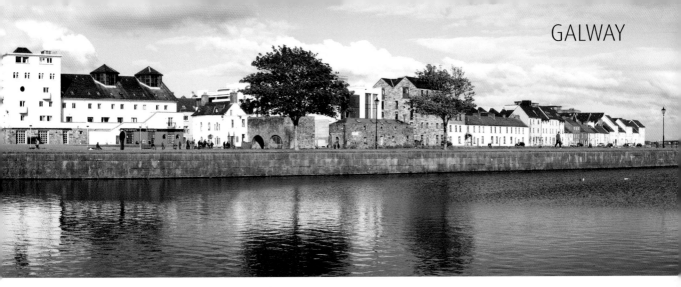

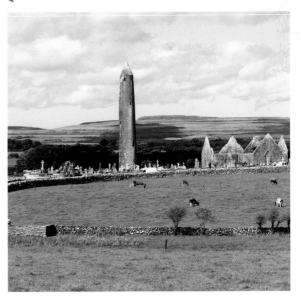

The Spanish Arch was originally part of the old city wall in Galway, extending to the quays at the area still known as the Claddagh, seen to the right in this photograph. It dates from 1584. In 1755, it was severely damaged by a tsunami generated by the great Lisbon earthquake. Lisbon is over 1,000 miles from Galway.

A musician in Galway city centre.

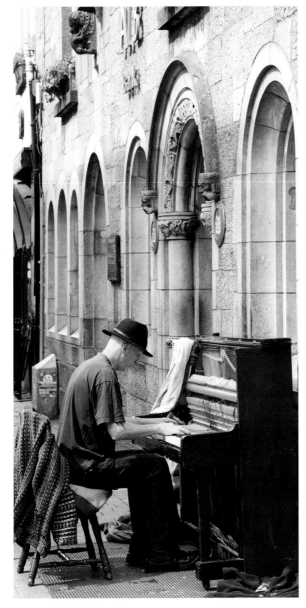

Kilmacduagh in south Co. Galway was once the seat of a separate diocese, although it has long since been absorbed by bigger consolidated dioceses. But, as this photograph demonstrates, it was clearly an important monastic and ecclesiastical centre. While much of it is ruinous, it still holds one of Ireland's better preserved round towers.

MAYO

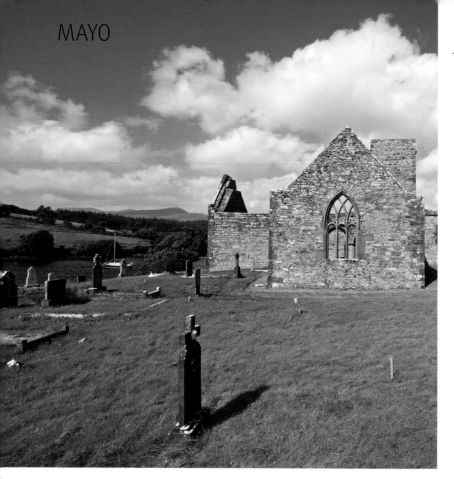

Burrishoole Friary near Newport, at the north-east corner of Clew Bay. This was a Dominican foundation dating from the late 15th century and, like so many other religious houses in Britain and Ireland, was a victim of the Reformation.

Now a five-star hotel, Ashford Castle has a long history. The first castle on this site at Cong, Co. Mayo, on the northern shores of Lough Corrib, was built by the de Burgo family in the 13th century. The de Burgos were one of the leading Hiberno-Norman families, whose surname was later Anglicised as Burke. Much of its present appearance dates from the 19th century, when it was owned by the Guinness family. ▼

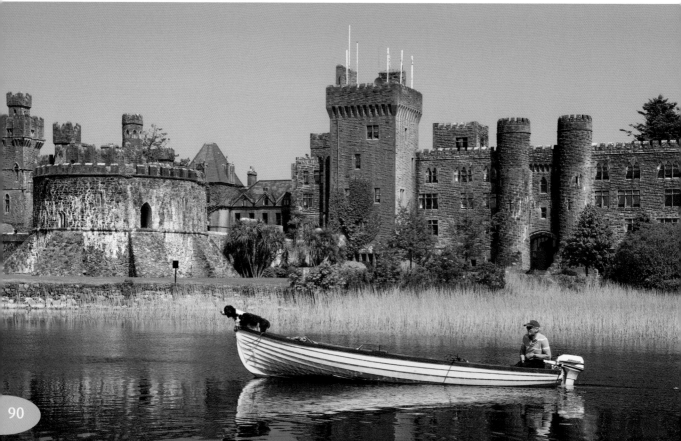

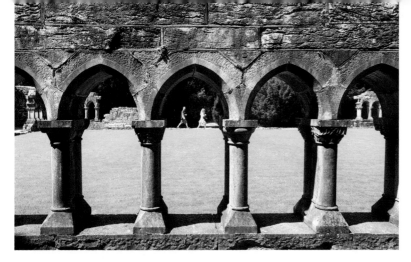

MAYO

Near Ashford Castle, the ruins of Cong Abbey are particularly impressive.

Lough Corrib, looking south. ▼

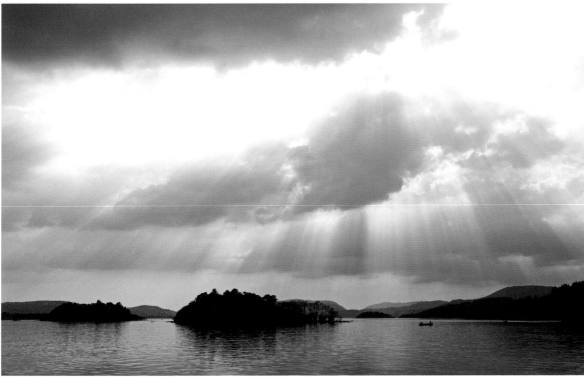

Clew Bay, showing just a few of its myriad islands.

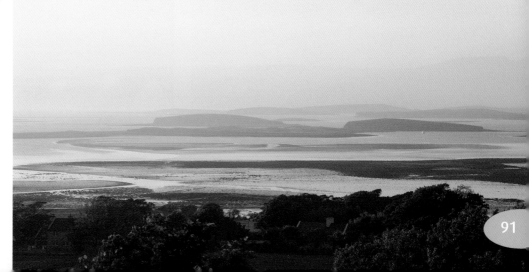

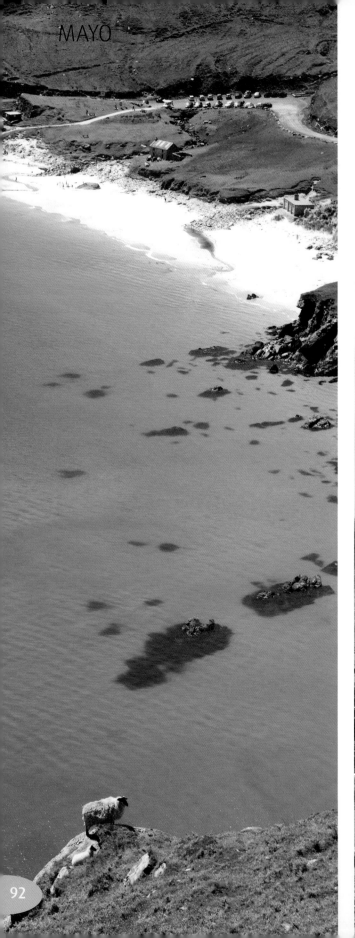

Keem Beach on Achill
Island. The largest island
off the Irish coast, Achill
is linked to the mainland
by a bridge.

Croagh Patrick, Ireland's holy
mountain, where St Patrick
is reputed to have spent 40
days and nights praying and
fasting. It overlooks Clew Bay.

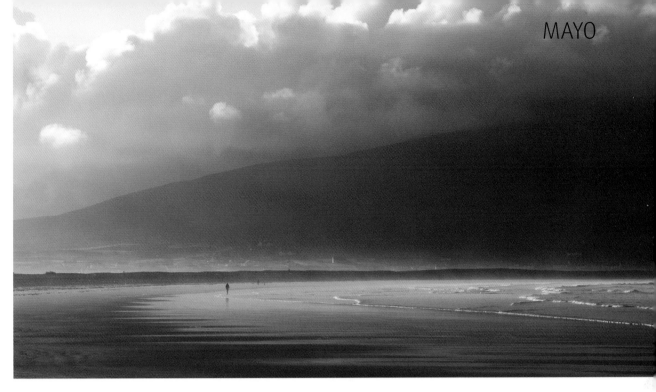

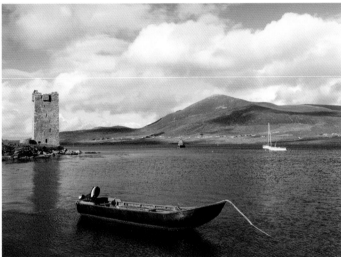

Achill occupies an area of 56 square ▲ miles, with upland rising to more than 2,000 feet. This was traditionally a remote and poor place, but its natural beauty has turned it into a visitor's paradise in modern times. The photograph on the left shows a tower house, of which there were many in this part of Ireland.

◄

Westport House is the finest classical residence in Connacht and one of the most distinguished in the whole country. It was designed by Richard Cassels, a German who was the fashionable architect in Ireland in the mid 18th century, and added to by James Wyatt. It is the seat of the Marquess of Sligo whose family – the Brownes – have lived here since the 17th century. It was originally a stronghold of the formidable O'Malley family, into which the Brownes married. ▶

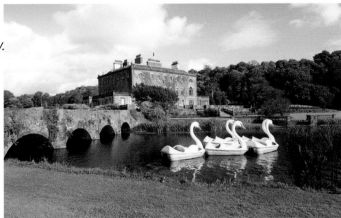

93

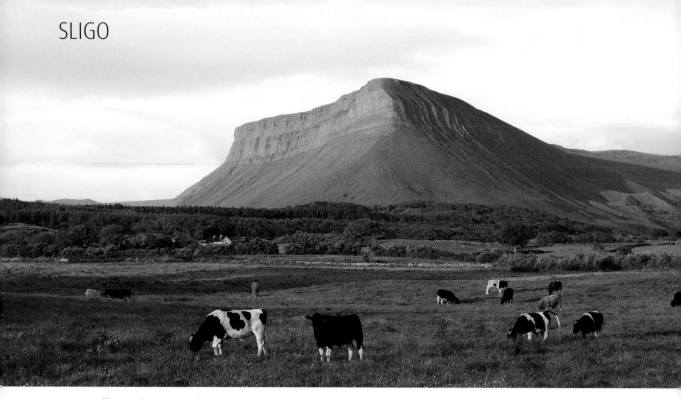

Ben Bulben, the most distinctive mountain in the west of Ireland and one indelibly associated with William Butler Yeats, who is buried in its shadow ('Under bare Ben Bulben's head/In Drumcliff churchyard Yeats is laid'). ▲

The beach at Inishcrone, Co. Sligo, just over the county border from Co. Mayo and near the east shore of Killala Bay. During the 1798 rising, a French fleet sailed into Killala Bay in support of the rebels. After some early victories, it was repulsed. ▼

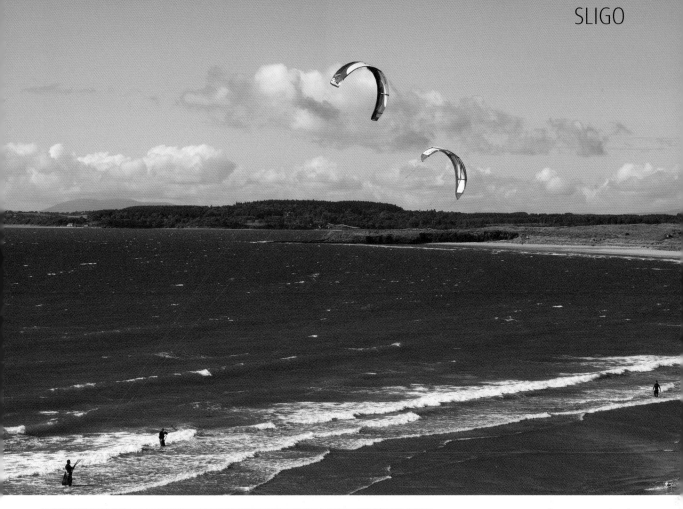

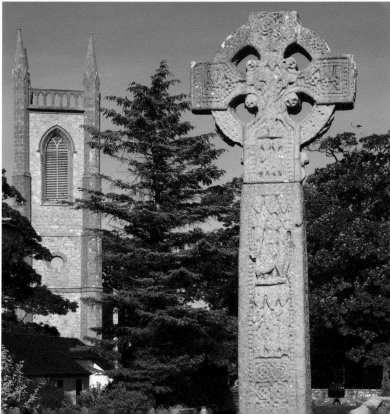

Rosses Point, to the west of ▲ Sligo town, is a seaside resort and contains a celebrated links golf course, the traditional home of the west of Ireland championship.

◄

The high cross at Drumcliff churchyard, near Yeats' grave. This was an ancient monastic site, as the cross attests. The cross dates from the ninth century, although the original foundation was some centuries older and is associated with St Columbkille, better known as St Columba, the evangelist of Scotland.

LEITRIM

The small county of Leitrim is a waterland and has the smallest population of all Irish counties. The headwaters of the Shannon flow through here, and there are many lakes, including the eastern end of Glencar Lake, which peeps across the county boundary from Sligo. It is here that the Glencar waterfall can be found.

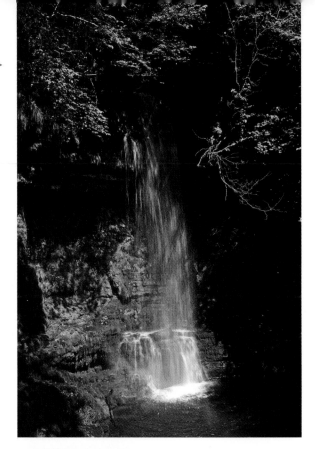

As with Glencar, Lough Gill also tips into Co. Leitrim at the eastern end and here we find Parke's Castle, a fine example of an early plantation castle. Prior to the 17th century, when Roger Parke was one of the new English settlers to secure north Connacht and the approaches to south-west Ulster, this site had been a stronghold of the Gaelic O'Rourkes.

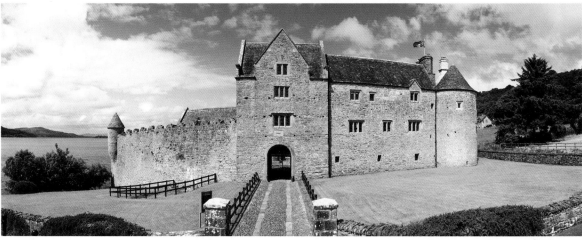

Near Dromahair. There is little good land in Co. Leitrim. As John McGahern, who was from the county, writes in the opening lines of his brilliant memoir: 'The soil in Leitrim is poor, in places no more than an inch deep. Underneath is daub, a blue-grey modelling clay, or channel, a compacted gravel.'

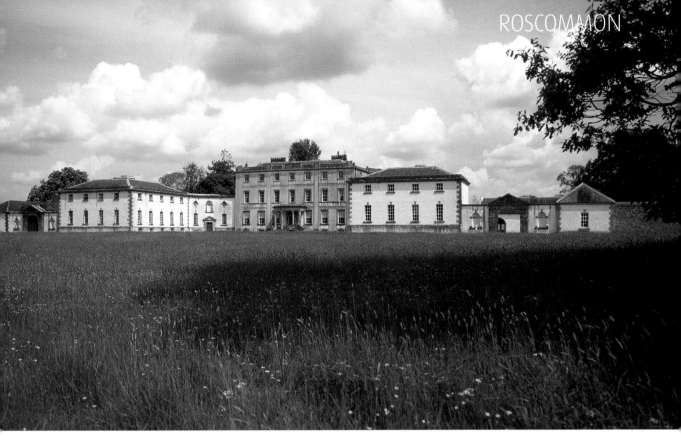

▲ Strokestown House, a huge classical residence in the town of the same name, was supported by a vast estate of more than 10,000 acres. It was the seat of the Mahon family, one of whom, Major Denis Mahon, was assassinated during the Great Famine. In modern times, it has been fully restored and now houses the Irish Famine Museum, which contains an invaluable depository of archival documents relating to that tragedy.

Lough Key Forest Park is the ▶ centrepiece of a region that offers superb river and lake cruising possibilities. All the counties west of the Shannon – the big river forms the eastern boundary of Co. Roscommon – are dotted with lakes and other watercourses.

ULSTER

Ulster is the northern province of Ireland, comprising nine counties. When the island was politically partitioned in 1920, the six central counties formed Northern Ireland and remained part of the United Kingdom, while the three marginal counties – the ones with the largest Catholic/nationalist majorities – joined what in due time became the Republic.

The natural boundaries of the province are a girdle of lakes and low hills called drumlins, which protect it to the south and run all the way from the Irish Sea to the Atlantic. Prior to the development of metalled roads and of the railway, there were very few access points from south to north into Ulster – and these were known and were defensible. Indeed, to this day the main road from Dublin to Belfast and the railway line run through one of these points. It is known as the Moyry Pass or otherwise as the Gap of the North. This natural line of defence helps to explain why Ulster was least affected by the Norman incursion of the 12th century – although, just to prove that there are exceptions to every rule, the adventurer John de Courcy did manage to establish himself near what is now Belfast (see Carrickfergus Castle, page 105).

In general, however, Ulster remained the most Gaelic of the Irish provinces until the final defeat of Gaelic Ireland by the expanding royal power of England around 1600. De Courcy's kingdom was but a historical memory by then. But if Ulster was different to the rest of Ireland in its resistance to incursion and invasion, it also meant that it had less connection with the rest of the island than the other three provinces.

Indeed, from ancient times Ulster's primary external focus was across the water to Scotland. At its narrowest point, the North Channel is only 12 miles wide and in the era before modern transport infrastructure was in place, the sea was a highway rather than barrier. It was a lot easier to get over to Scotland from the coast of Ulster than it was to get to the Irish midlands or to Dublin. The early Gaelic kingdom of Dál Riata straddled the North Channel, embracing north-east Ireland and south-west Scotland. The Scottish county of Argyll – where Bonny Mary hailed from – was a large part of the Scottish end of Dál Riata; in short, there was a common culture on either shore of the narrow sea. Nor is it any surprise that Christianity first came to Scotland through Dál Riata – Ireland had been evangelised earlier than northern Britain – or that the foundation saint of Scottish Christianity, St Columba, was from over the water, near where Derry now is.

Ulster was always different, and that difference was magnified by the dramatic effects of the 17th-century Plantation. Following the defeat and flight of the Gaelic lords, their lands were declared

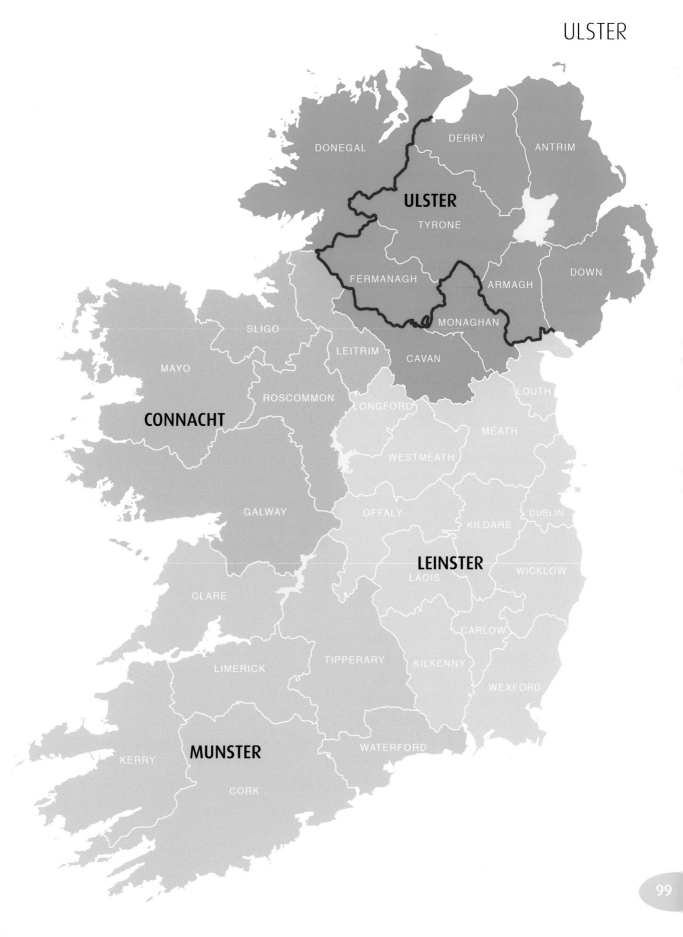

ULSTER

DONEGAL

DERRY

ANTRIM

TYRONE

DOWN

FERMANAGH

ARMAGH

MONAGHAN

SLIGO

LEITRIM

CAVAN

LOUTH

MAYO

ROSCOMMON

LONGFORD

MEATH

CONNACHT

WESTMEATH

GALWAY

OFFALY

DUBLIN

KILDARE

LEINSTER

WICKLOW

LAOIS

CLARE

CARLOW

LIMERICK

TIPPERARY

KILKENNY

WEXFORD

MUNSTER

WATERFORD

KERRY

CORK

forfeit to the English crown, which settled these lands with English and Scottish migrants. The crucial feature of these settlers was their religion: they were Protestant. Ireland (and not just Gaelic Ulster), on the other hand, had rejected the Reformation and was the one large, coherent part of the English royal domain to remain loyal to Catholicism.

Thus Ulster went, in the 17th century, from being the most Gaelic, Catholic and traditional Irish province to being the most disrupted. Its traditional Gaelic aristocracy was now replaced by a settler population, which developed over time a ferocious frontier culture not unlike that of the Prussian Junkers in the German Baltic provinces. The population of Ulster was now divided in religious allegiance, although mainly Protestant. Moreover, it was generally more modern in its society and economy than the three provinces to the south.

This was rammed home with cruel emphasis in the middle of the 19th century. From 1845 to 1852, Ireland was ravaged by the Great Famine. It was the last great subsistence crisis in the history of Western Europe. Out of a pre-Famine population of more than 8 million, death, disease and emigration accounted for the loss of two million people in a decade. Ulster was touched by this catastrophe as well as the rest of the island, but to a lesser degree than the three southern provinces. And the reason for this was simple: the Industrial Revolution.

The province had developed a thriving linen industry in the 17th and 18th centuries but now, in the middle of the 19th, it added heavy industry and urbanisation. Belfast's population went from about 25,000 in 1800 to more than 300,000 in 1900. Shipbuilding, textiles, tobacco and heavy engineering came to dominate the late Victorian economy of east Ulster, which became in effect part of the industrial economy of north-west Britain, like Lancashire or Scotland. Once again, the outward pulse of Ulster life was directed across the water rather than inland to the rest of Ireland.

It was, however, a disproportionately Protestant and unionist phenomenon; the industrial capitalists and the aristocracy of labour that served them were overwhelmingly so. In the heyday of industrial Ulster, Catholics were more commonly found in the rural south and west of the province or, in the case of those post-Famine Catholics that had flocked to the industrial east for employment, confined to subordinate and relatively unskilled positions. They looked with hope to the three southern provinces where their co-religionists were struggling first for domestic autonomy from Britain and later for separation.

When the south achieved this state of bliss, it was at the price of partition. Ulster unionists simply refused to be lumped into an overwhelmingly Catholic state. Instead, partition was the solution that everyone had to live with. But not only was Ireland partitioned, Ulster was partitioned as well.

The unionists only wanted the six counties that could guarantee them a permanent internal majority. The full nine counties would have had a small nationalist majority, which would, of course, have immediately voted itself into the southern state.

Instead the situation was reversed. It was now the Ulster Catholics who felt abandoned to their tribal enemies. They refused to participate in the new Northern Ireland institutions, which in turn treated them as second-class citizens. London, the sovereign power, was glad to be shut of the intractable Irish mess that had vexed its politics for so long, and looked the other way in the face of petty anti-Catholic discrimination that simply would not have been tolerated in any other part of the United Kingdom.

The internal pressures of Northern Ireland eventually erupted in the long tragedy of the Troubles, with results that need no elaboration here.

For all this turbulence, what strikes the visitor is how normal Ulster is. This was true to a surprising degree even during the Troubles. There was a civil society that ran in parallel to all the mayhem and which helped to maintain the hope that was eventually rewarded. Northern Ireland was never like Lebanon or Somalia. And now, with the peace dividend, visitors can once again discover that it is a really beautiful province, friendly and welcoming. There is hardly a road anywhere more beautiful than the Antrim Coast Road from Larne to Ballycastle. Derry is a gem of a small city. Armagh is lovely. The Fermanagh lake land is a hidden treasure. You'll like it up there.

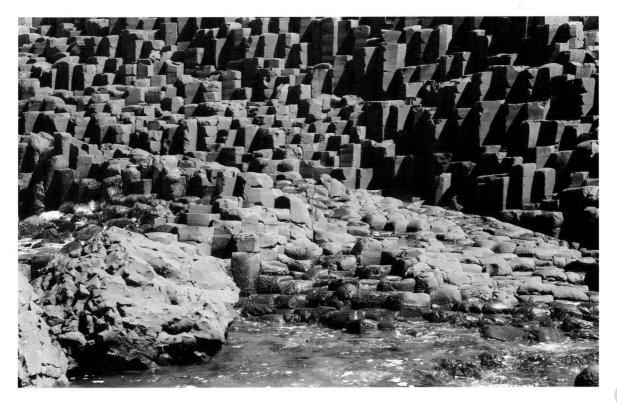

The Giant's Causeway, Antrim.

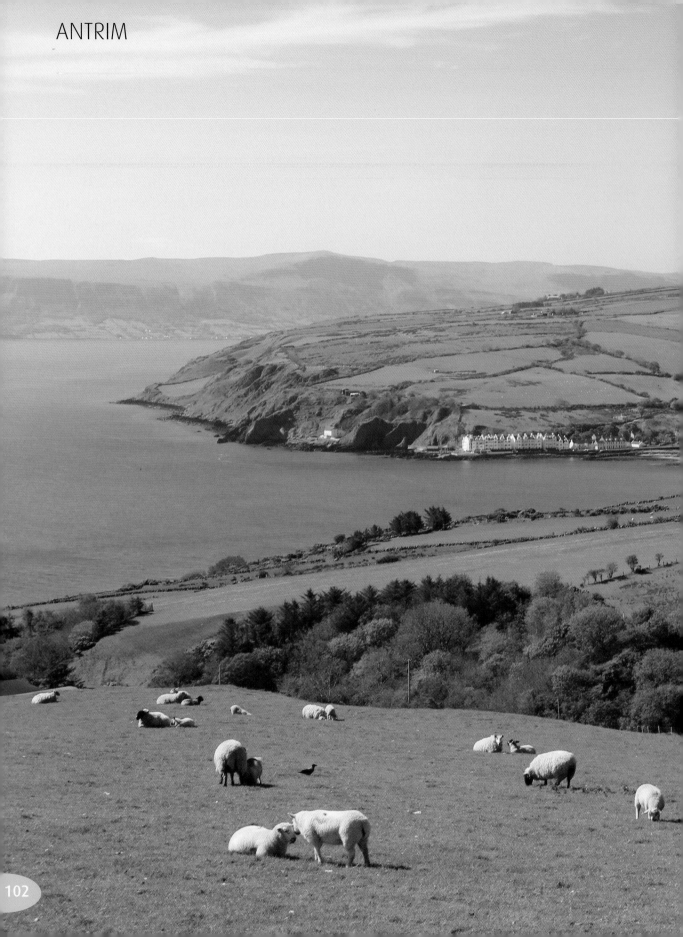

ANTRIM

Cushendun Bay, on the beautiful Co. Antrim coast.

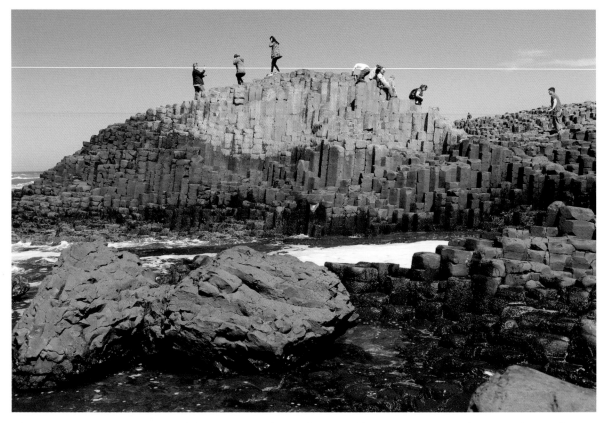

The Giant's Causeway, one of the most celebrated natural features in Ireland. Formed by volcanic basalt about 60 million years ago, it was famously – if wrongly – described by Samuel Johnson (who never saw it) as 'worth seeing, but not worth going to see'.

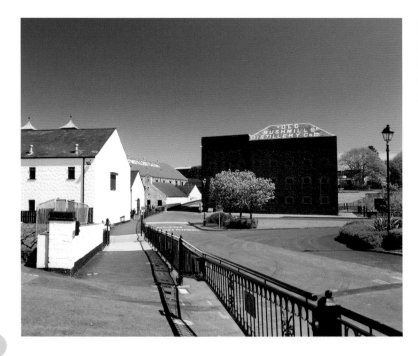

Bushmills Distillery, in the small town close to the Giant's Causeway, is the oldest distillery in Ireland. It has been in continuous production since 1609.

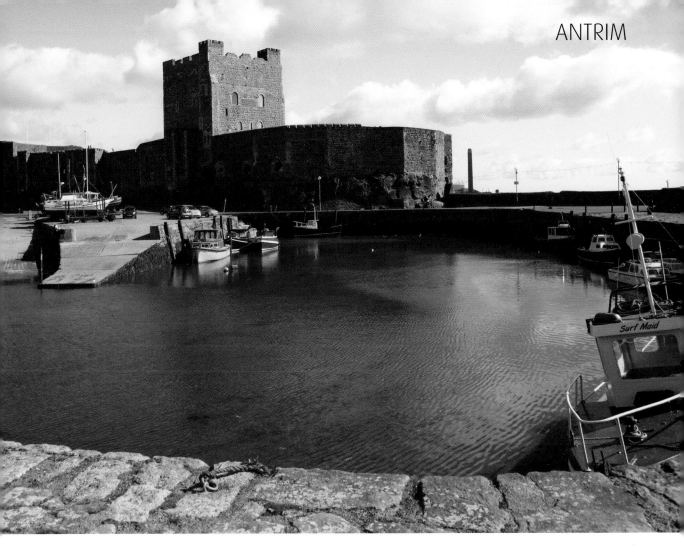

▲ *Carrickfergus Castle, just to
the north of Belfast, stands
on a promontory on the north
shore of Belfast Lough. It was
built by John de Courcy, one of
the more enterprising of the
early Norman warlords, in the
late 12th century. De Courcy
established what was in
effect a private sub-kingdom
based on this impregnable
fortress. Even after more
than 800 years, it still looks
formidable.*

*The Antrim coast looks across to Scotland, which is visible in
clear weather. At the narrowest point, there are only 12 miles
of water between Ireland and the Mull of Kintyre.*

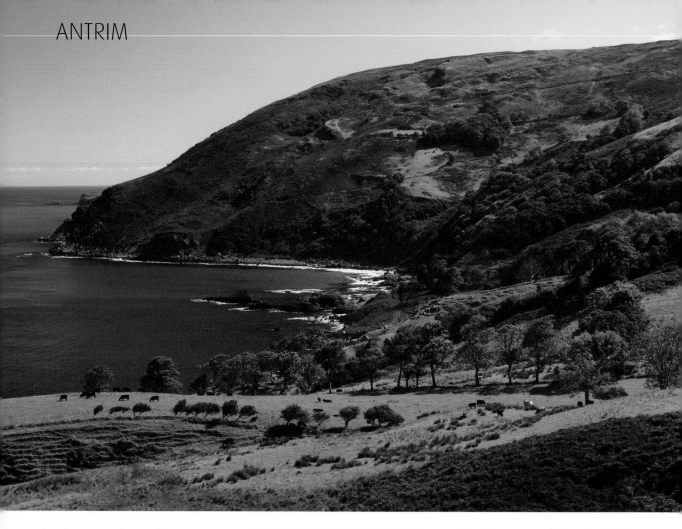

▲ *The nine glens of Antrim are, together with the Giant's Causeway, the county's most distinctive natural feature. The nine glens sweep down from the inland Antrim plateau, which rises to about 1,200 feet, until they meet the sea. They have carved out a dramatic U-shaped landscape.*

▶

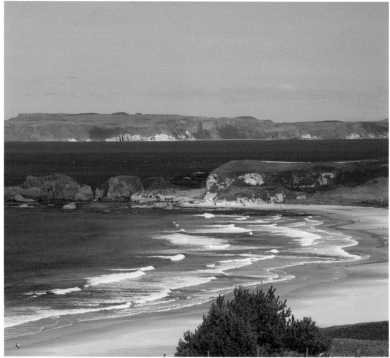

The beach at Ballycastle, with Fair Head in the background. Fair Head is at the north-east corner of Ireland, the closest point on the Irish mainland to Scotland.

Slieve Gullion dominates the countryside in south Armagh, close to the Irish border. It also gives its name to a large forest park centred on the mountain.

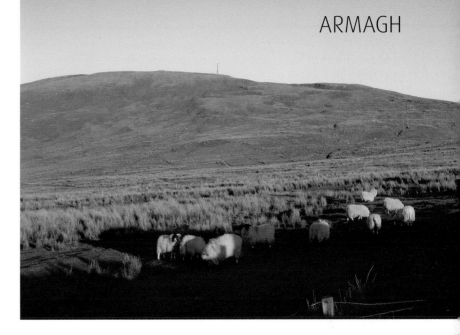

The small city of Armagh is the ecclesiastical capital of Ireland, based on a claim dating all the way back to St Patrick. Its central core is a little Georgian gem. The Anglican cathedral, seen here in the distance, was the centrepiece of an ambitious late 18th-century development of the city by Archbishop Robinson.

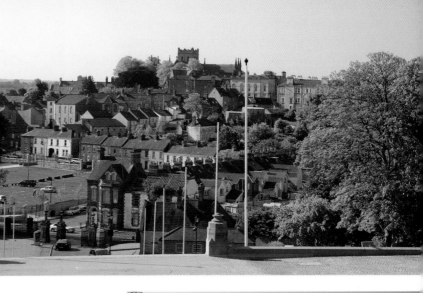

Co. Armagh is called the Orchard County and it's not hard to see why. It is famed for its orchards, which form a pleasant backdrop to its small country lanes. ▼

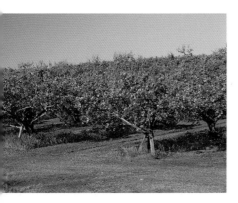

The Mall in the centre of Armagh was originally a commons, which Archbishop Robinson turned into a public walkway. It was further developed to assume its present appearance in 1810.

▶

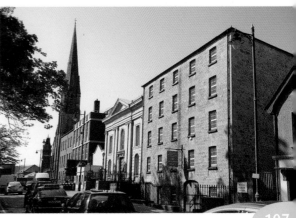

BELFAST

Belfast City Hall was built at the height of the city's industrial success and completed in 1906. It is a proud assertion of urban and civic confidence, standing as it is at the very centre of the city on the site previously occupied by the White Linen Hall.

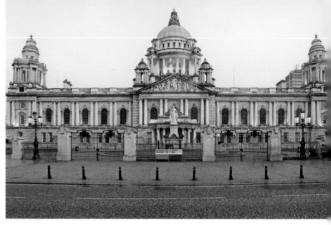

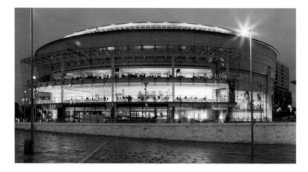

Self-confident architecture in central Belfast from its Victorian heyday. ▼

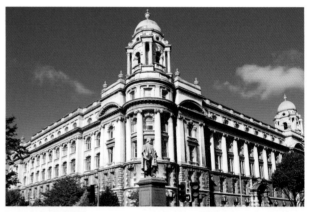

The Waterfront Hall in Belfast, designed ▲ by local architects and built during some of the worst years of the Northern Ireland Troubles. This fine building is a reminder of the continuing sense of civic self-possession that the city always retained, even in the most trying circumstances.

Belfast by night. ▼

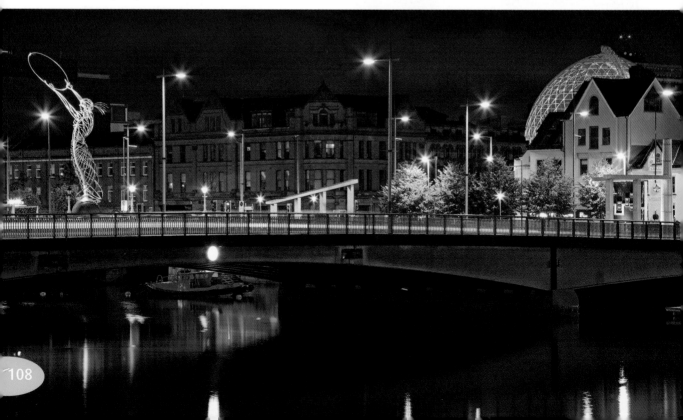

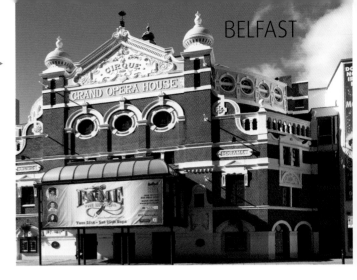

A piece of marvellous late Victorian whimsy, ▶
Belfast's Grand Opera House has survived
bombs, changes of fashion and taste, and
everything that time could throw at it to retain
its place at the heart of the city and in the
hearts of its citizens.

Belfast has emerged from the bad years of the
Troubles with a renewed sense of pride and
confidence. This riverside development can
stand for many others, as the city faces the
future with hope. ▼

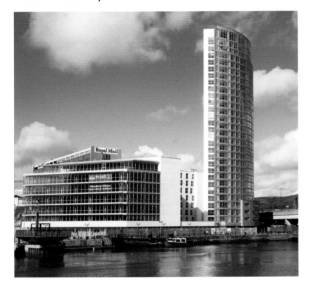

The Robinson & Cleaver building on Donegall
Square, across from the City Hall, was once the
grandest department store in Belfast. Officially
called the Royal Irish Linen Warehouse, it opened
in 1888 and was already in decline when the
Troubles started. They proved fatal and it closed
in 1984. However, at its peak, it was estimated
that one in three parcels sent overseas from
Belfast originated in this one shop. ▼

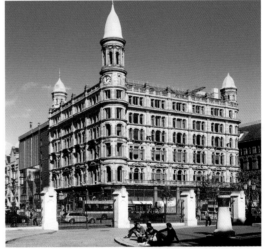

Modern street furniture
in Belfast city centre.
◀

The interior of the ▶
Crown Liquor Saloon,
directly across the street
from the Grand Opera
House. This magnificent
gin palace has been
restored to its full
Victorian splendour and
is now owned by the
British National Trust.

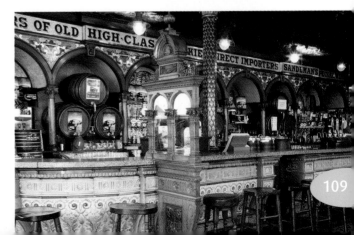

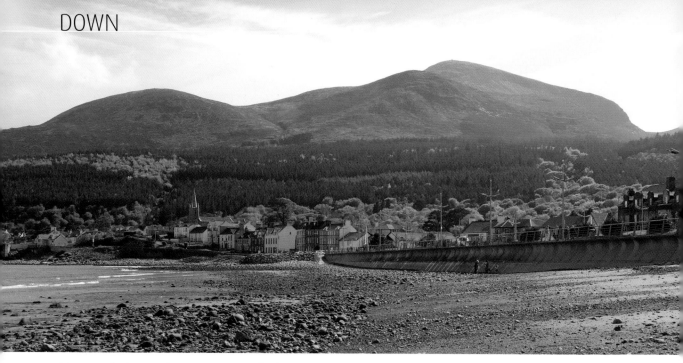

Newcastle in south Co. Down, with Slieve Donard, the highest of the Mourne Mountains, imposing in the background.

The plaque marking the site of St Patrick's burial place.

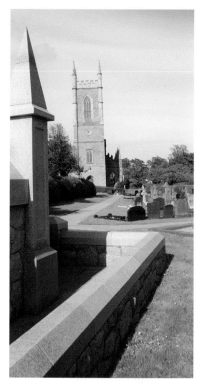

Killyleagh is a small town on the western shore of Strangford Lough. It is dominated by this fine castle, which is the oldest inhabited castle in Ireland in private ownership. The original building dates from the 1660s, but the turrets and ornamentation that give it its exotic appearance date from the mid 19th century.

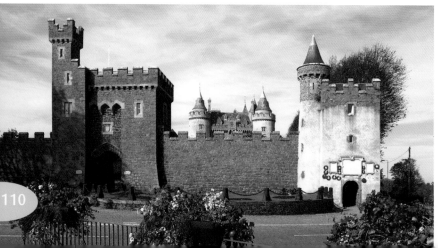

The Anglican church and graveyard in Downpatrick, the reputed site of St Patrick's grave.

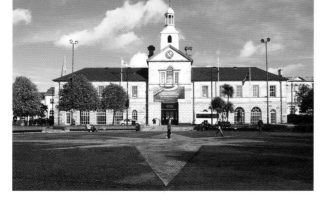

Newtownards stands at the head of Strangford Lough. It is named for the Ards Peninsula, which forms the east side of the lough. There were monasteries here in early Christian and medieval times, but the modern town dates from the 17th-century Plantation of Ulster. This photograph shows the impressive town hall.

Strangford Lough is a long sea inlet that penetrates into the heart of Co. Down, south-east of Belfast. It is an idyllic location for pleasure boats of all sorts.

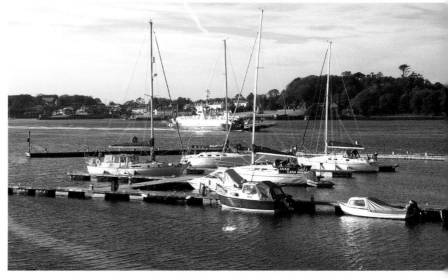

The small harbour and lighthouse at Donaghadee, Co. Down, on the Ards Peninsula.

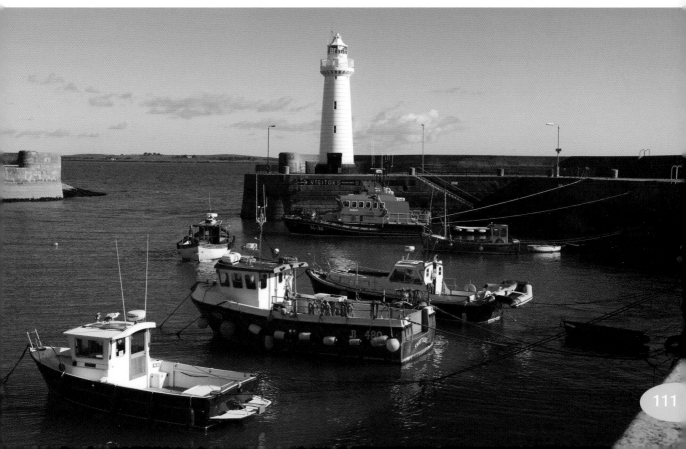

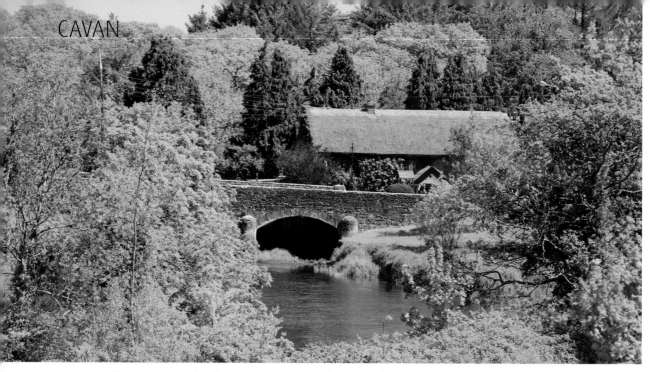

Cavan is the most southerly county in Ulster, forming the provincial boundary with Leinster to the south and Connacht to the west. Its landscape is dominated by water, with its necklace of lakes. Towards the north of the county lies the pretty village of Butlersbridge, whose eponymous bridge is shown here. The river is the Annalee, a tributary of the River Erne, which drains the two large lakes of the same name in the neighbouring county of Fermanagh.

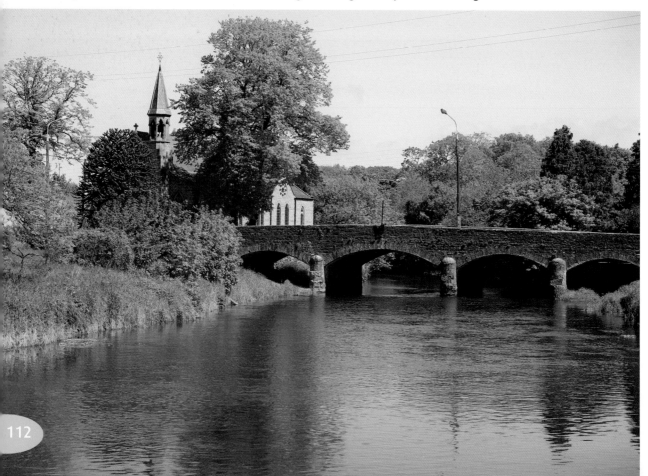

The Shannon-Erne Waterway is a canal, 39 miles long, that links the River Shannon to Lough Erne. Built in the middle of the 19th century, the canal was a commercial failure and fell into decline for many years. Because it straddled the border between Northern Ireland and the Republic, political difficulties inhibited attempts at restoration. However, it was eventually restored as a resource for leisure craft in 1994.

Port Lake is one of the many lakes in Co. Cavan, in the middle of which stands St Mogue's Island. It is named for a sixth-century saint who was a native of those parts.

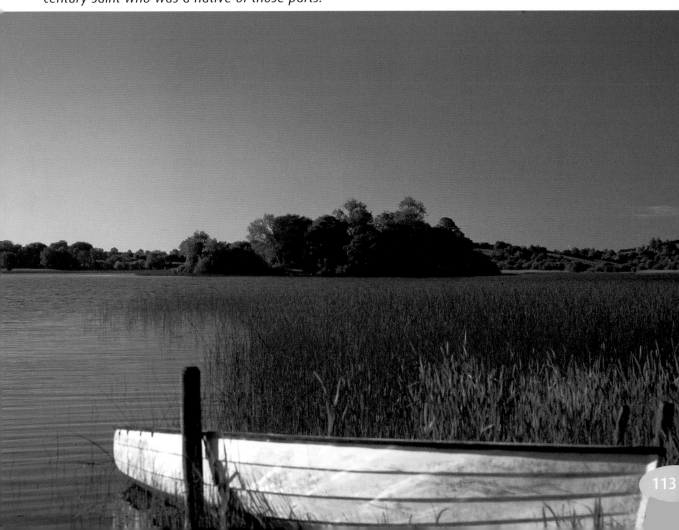

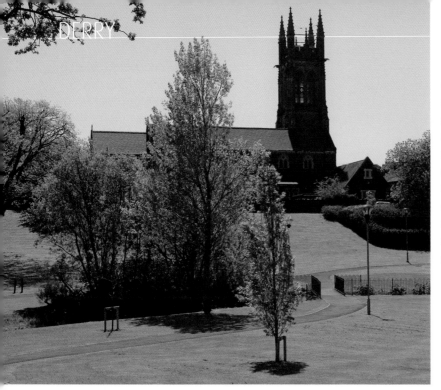

The town of Coleraine stands near the mouth of the River Bann, the river that drains Lough Neagh, the largest freshwater lake in Britain and Ireland. This handsome church and park are a feature of the town. Near Coleraine is the Mesolithic site of Mount Sandel, where the earliest evidence of human habitation in Ireland was found. The site has been dated to 5935 BC.

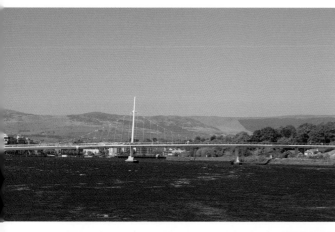

The city of Derry has made a wonderful recovery from the dreadful years of the Troubles, as this new bridge over the Foyle estuary demonstrates. The Foyle, a modest river, suddenly billows out into a wide estuary at Derry. The city, which is sited at the very western margin of Northern Ireland only a few miles from the border with the Republic, was the UK City of Culture for 2013.

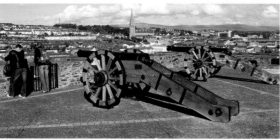

Derry was the last city in Europe to build an encircling defensive wall, which is still extant. In 1689, the little town within the walls held out for the Williamite cause and withstood a Jacobite siege of 105 days. As this picture demonstrates, old artillery pieces are still preserved on the walls.

The streets within the walls are built on a cruciform grid, at the centre of which stands the Diamond. In the centre of the Diamond, the war memorial honours local men who fell in the two world wars.

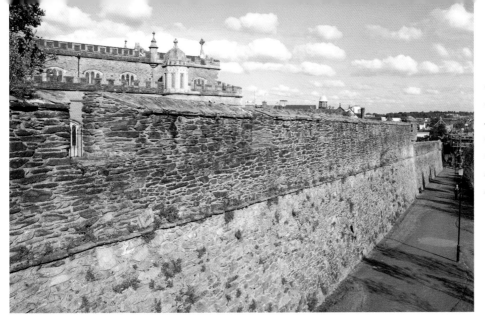

The walls of Derry are imposing, as this image shows. Part of St Columb's Cathedral can be seen in the background.

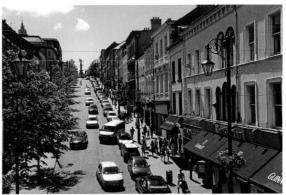

Shipquay Street in Derry runs uphill from the Shipquay Gate in the walls, the one nearest to the river as the name suggests, to the Diamond at the top of the hill.

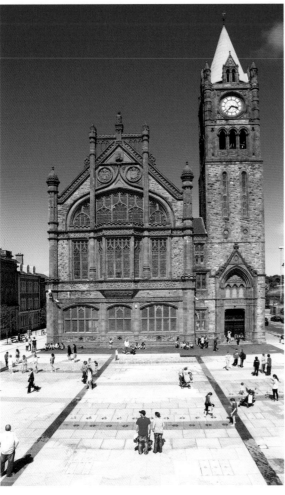

The Guildhall, probably the most recognisable building in the city, stands just outside the walls beside Shipquay Gate. It has been the centre of civic life in Derry since it opened in 1890.

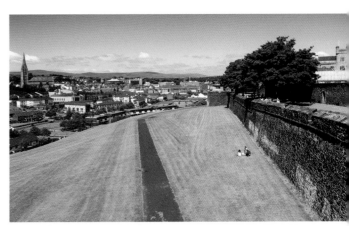

Derry outside the walls. Most of the modern city lies outside the old walled town and spreads across the river to the east bank.

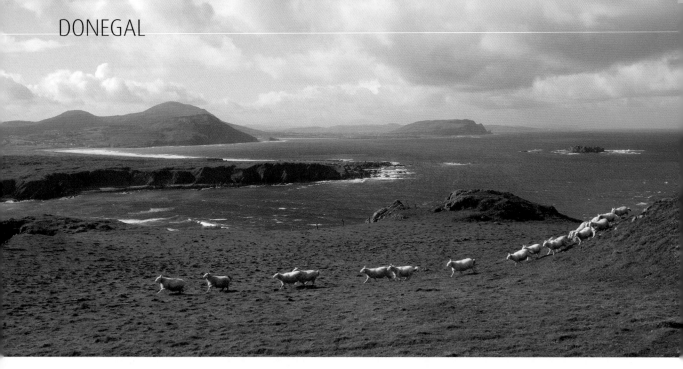

▲ Although Donegal is the most northerly county in Ireland, it is in the Republic (the South). Malin Head is in turn the most northerly part of the county and of the island as a whole.

Fort Dunree at Buncrana on the Inishowen Peninsula lies in Co. Donegal between Lough Foyle, the river estuary below Derry to the east, and Lough Swilly, a deep inlet of the Atlantic to the west. It means that Inishowen is semi-detached from the rest of the county. ▶

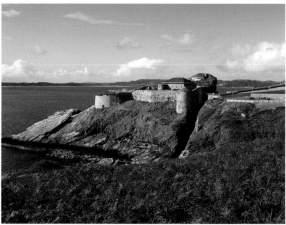

Doe Castle near Creeslough in north Co. Donegal is a former stronghold of the Sweeney clan. It is sited on a small promontory, surrounded by water on three sides and with a defensive moat on the landward side. The castle dates from the 16th century. ▼

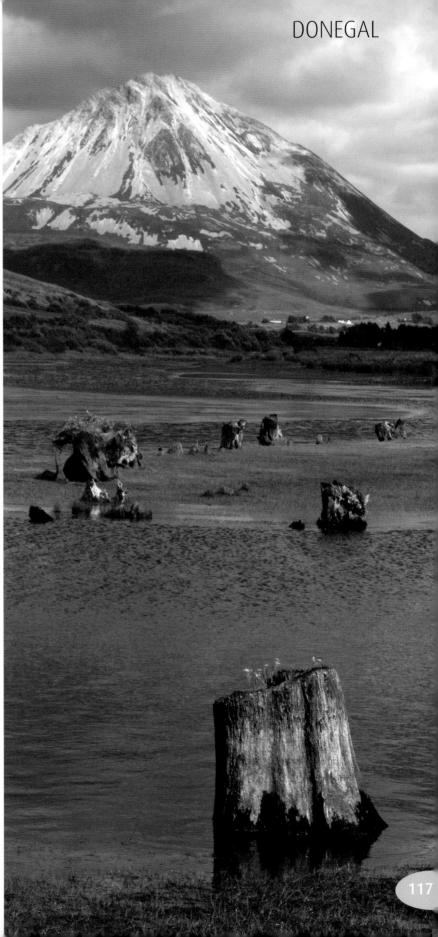

Mount Errigal, the highest mountain in Donegal and an emblem of the county. Donegal is a popular tourist county, not least with people coming over the border from Northern Ireland. Its rugged beauty and magnificent coastline make it a paradise, especially in fine summer weather.

Doe Castle in north Co. Donegal.

DONEGAL

Greencastle is an attractive town on the ▶
east coast of the Inishowen Peninsula. This
photograph shows the town's maritime
museum and planetarium.

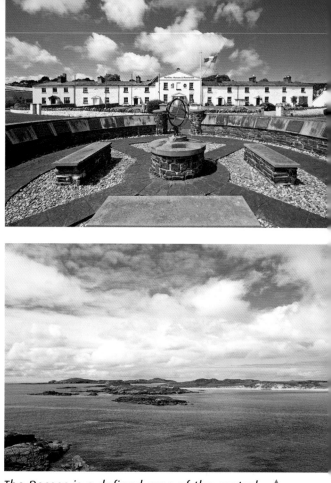

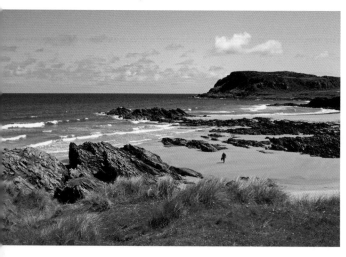

▲ Culdaff is a village on the Inishowen peninsula
known for its beaches. The beaches in Donegal
are fabulous and far less crowded than those
further south.

The Grianan of Aileach, a dramatically sited
hill fort from the Late Bronze Age or the Early
Iron Age. It stands just to the west of Derry, in
east Donegal, and commands views of Loughs
Swilly and Foyle. It was a defensive enclosure,
almost 70 yards in diameter. A grianán was a
summer house – grian is the Irish for sun – and
this one was probably built by the local Gaelic
kings of this region, then known as Aileach. ▼

The Rosses is a defined area of the central ▲
Donegal coast, running roughly from the
village of Gweedore in the north to that of
Glenties in the south and centred on the town
of Dunglow. It is a particularly beautiful part of
a particularly beautiful county.

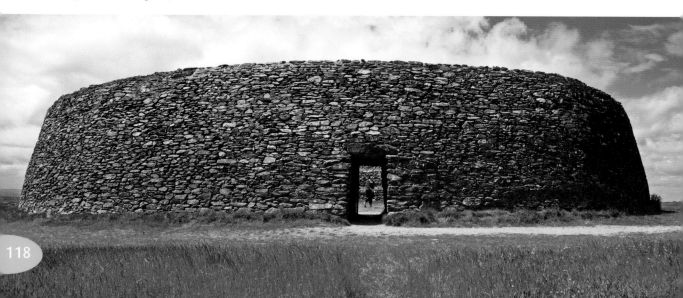

DONEGAL

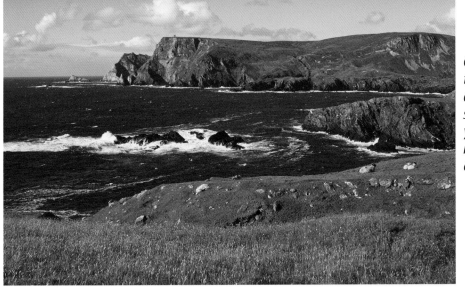

Glencolumbkille in the far south-west of Co. Donegal is a small parish with yet more stunning marine views and dramatic coastline.

Donegal Castle, in the town of Donegal in the south of the county, was for a thousand years the principal seat of the Clan O'Donnell, lords of Tír Conaill (later anglicised as Tyrconnell and later again renamed as Donegal). Until the collapse of Gaelic Ireland in the face of the Elizabethan and Jacobean English conquest either side of 1600, this was one of the most potent centres of power in Gaelic Ireland and without challenge in this corner of the island.

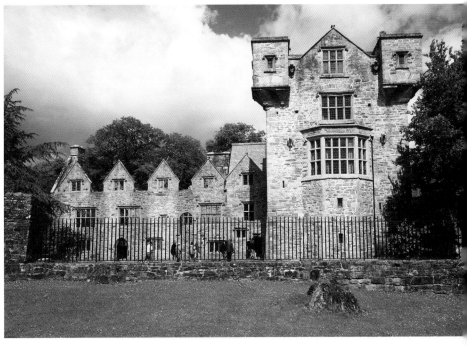

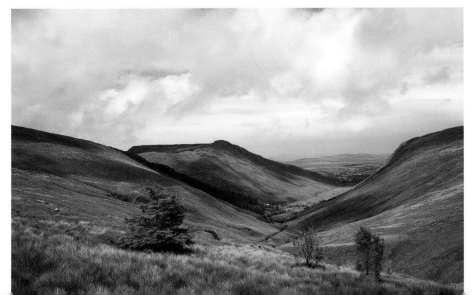

Glengesh Pass in the south-west of Co. Donegal.

DONEGAL

The central square or display area in many Ulster towns is called the Diamond, as here in Donegal town.

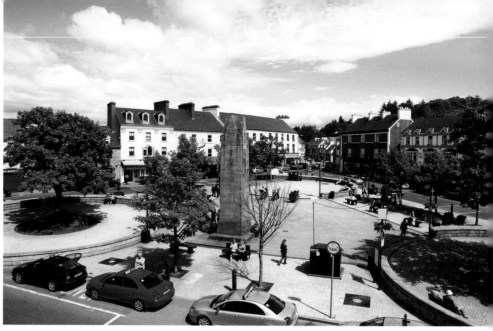

These magnificent cliffs at Slieve League on the south-west coast of Co. Donegal are among the finest and most dramatic in Western Europe.

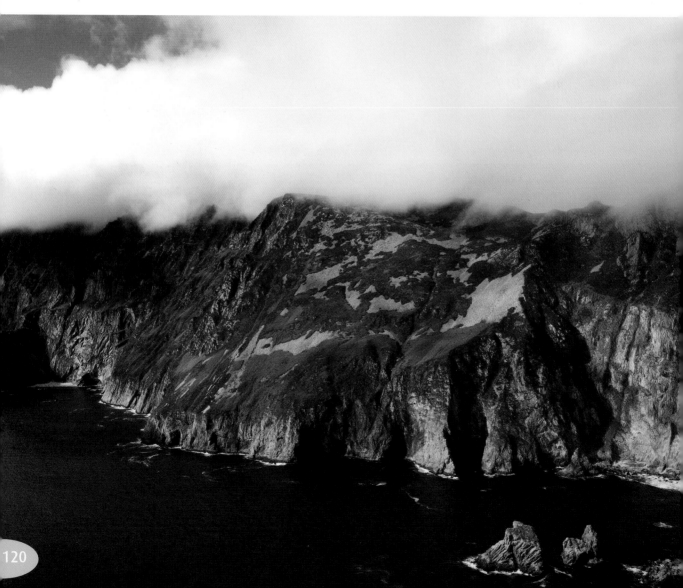

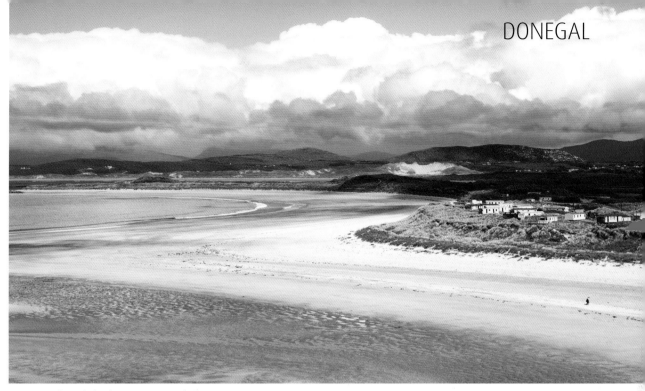

Yet another fabulous Donegal beach, this one at Narin – one of the very finest ...

... and another! Five Finger Strand on the Inishowen Peninsula. Wish you were here!

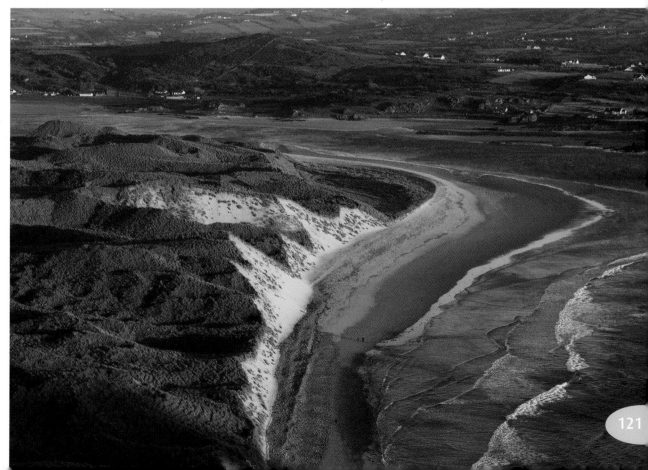

FERMANAGH

Like its Cavan neighbour over the border, Co. Fermanagh is also lake country. But unlike Cavan, it is less a network of small lakes than a county dominated by two – or perhaps that should be one. The two parts of Lough Erne, the upper and lower lakes (the lower being, as always in Ireland, the one nearer to the sea), are the defining feature of the county and effectively divide it in two. This extraordinary stone Janus-faced carving of an idol stands in Caldragh graveyard on Boa Island in the lower lake. The carving – whose image is repeated on the obverse – is dated to the Iron Age.

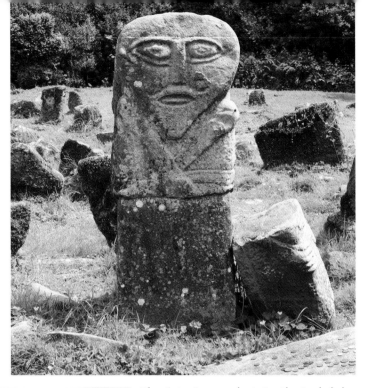

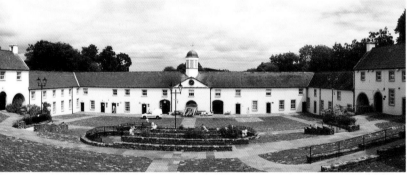

The interior yard at Castle Archdale, on the shores of the lower lake, is a classic Plantation house. It sits on land at the very western extent of the Ulster Plantation, which has always given Co. Fermanagh something of a frontier culture.

Florence Court, also in Co. Fermanagh, was one of the greatest of Irish country houses and a symbol in stone of early Irish classicism. More correctly, it was European classicism – not just in stone but also in landscape – imported to the western margins of English and European aristocratic settlement. ▼

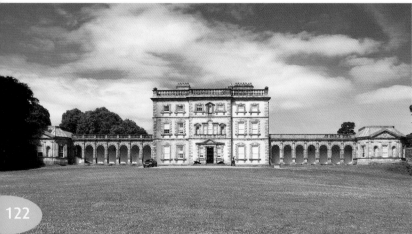

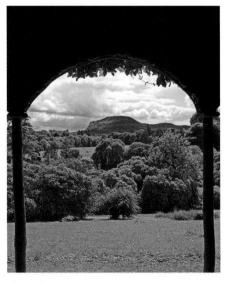

The view at Florence Court.

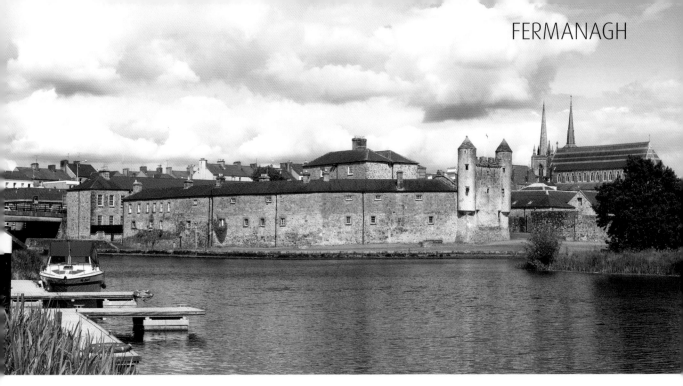

Enniskillen Castle, dominating the county town of Fermanagh at the southern end of the lower lake. Originally a stronghold of the Gaelic clan Maguire, it was remodelled by the Cole family – one of the key Plantation families in Co. Fermanagh – from the early 17th century.

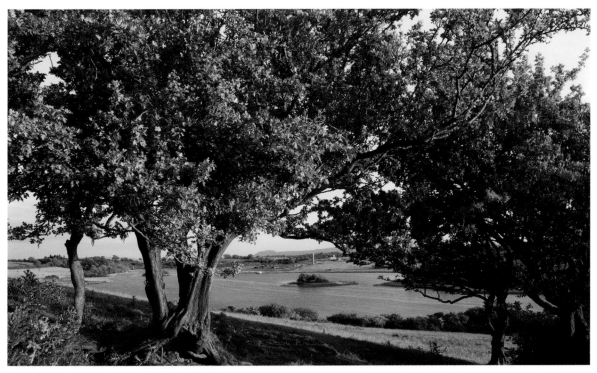

Devenish Island on Lower Lough Erne. A monastery was established here by St Molaise in the sixth century. There were two round towers here, of which one has survived and can be seen in this photograph. In the late medieval period, there was an Augustinian priory here, an idyllic place in which to practise the vows of denial and to offer prayers for the salvation of humanity.

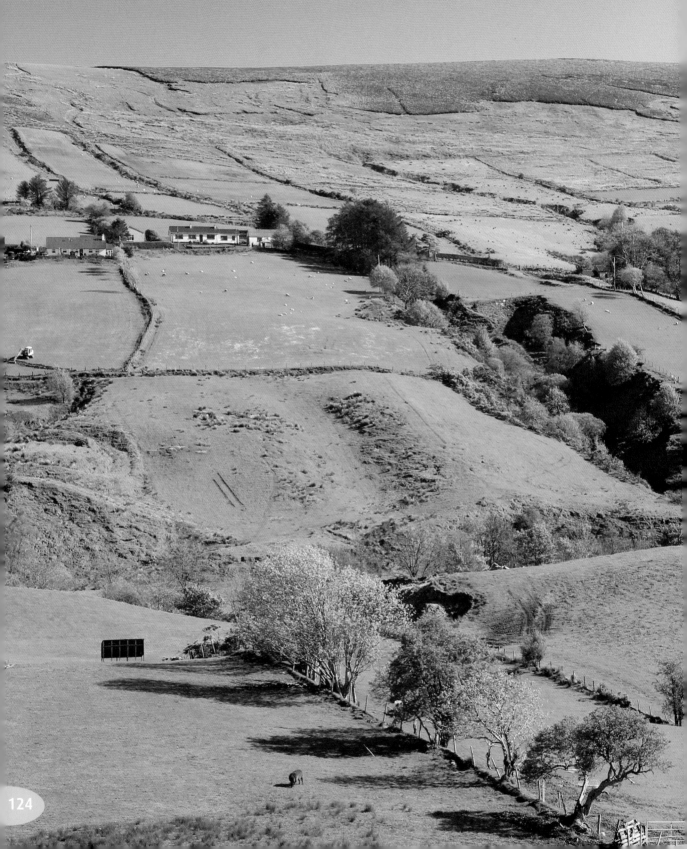

Tyrone is the central inland county of Ulster and the largest county by area in Northern Ireland. It was the heartland of the Clan O'Neill in Gaelic times. But with the collapse of Gaelic Ireland at the end of the 16th century, it became one of the plantation counties. Its principal topographical feature is the upland area known as the Sperrin Mountains, of which one of its prettier landscapes, Glenelly Valley, is shown here.

TYRONE

In the west of Co. Tyrone is an interesting example – unusual in Ireland – of enlightened industrial urban planning. Sion Mills is a linen town, part of a tradition in provincial Ulster that flourished both before and during the industrial revolution. In the middle of the 19th century, the Herdman brothers, James, John and George, established their mill here on the banks of the River Mourne. They also laid out the pretty village for their workers. The photograph shows Herdman's Mill, the focal point of the village.

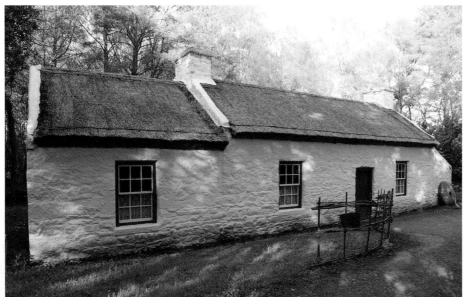

A cottage at the Ulster American Folk Park near Omagh, the county town of Tyrone. The park celebrates the strong connections between Ulster and the United States and the millions of Americans who can claim descent from Ulster emigrants in times past.

Lough Neagh touches five of the six counties of Northern Ireland and is the largest freshwater lake in the British Isles. It is recorded that in the famine winters of 1740 and 1741 – some of the coldest weather ever recorded in Ireland – the lake froze so solid that people could walk across from one side to the other – from Co. Tyrone to Antrim.

MONAGHAN

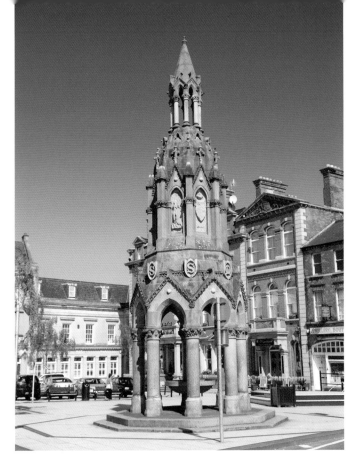

The town centre of Monaghan, principal settlement in the county of the same name. It is an Ulster county bordering Cavan and Co. Louth (in Leinster) to the south, but really orientated northwards. Its northern part is essentially a salient that pushes deep into Ulster as far as Co. Tyrone. Still, it is part of the Republic, because its Catholic majority population were nationalist when the partition of Ireland was determined in 1920 and confessional allegiance was the litmus test of political choice.

Rural landscape
in Co. Monaghan.

CREDITS

For permission to reproduce photographs, the publisher gratefully acknowledges the following:

© Alamy: 76TR; Alamy/AM Stock: 72TL; Alamy/ David Lyons: 39T; Alamy/Design Pics Inc: 39BR; Alamy/George Munday: 43C; Alamy/ incamerastock: 20B; Alamy/Maurice Savage: 28T; Alamy/National Geographic Image Collection: 73C; Alamy/NiKreative: 56CR; Alamy/Robert Harding Picture Library Ltd: 76TL; Alamy/ Sarah Hadley: 72B; Alamy/scenicireland.com/ Christopher Hill Photographic: 56TR, 69TR; Getty Images/Chris Hill: 72TR; Getty Images/DEA/G. DAGLI ORTI: 39BL; Getty Images/Design Pics/Ken Welsh: 57B; Getty Images/Dori Oconnell: 57T; Getty Images/Joe Cornish: 76B; Getty Images/ Panoramic Images: 43B; Getty Images/Trish Punch: 56BL; Michael Diggin: 10TL, 10TR, 21C, 22T, 22C, 22BR, 22BL, 36T, 36C, 38T, 38BL, 40T, 40BL, 40BR, 41B, 41T, 42T, 58B, 58T, 59TL, 59TR, 59B, 60T, 60C, 60B, 61B, 68CR, 68CL, 68T, 68B, 70B, 70CR, 73T, 82TL, 82CR, 97T, 97B, 101, 102 - 103, 104T, 104B, 105T, 105B, 106T, 106B, 107T, 107BL, 107C, 107BR, 110T, 110CR, 110CL, 111B, 112B, 112T, 113B, 113T, 114T, 114CL, 124 - 125, 126T, 126C, 126B, 127T, 127B; Peter Zoeller: 1,

2 - 3, 9, 10B, 11T, 11C, 11B, 12T, 12B, 12L, 13T, 13C, 13B, 14T, 14B -15B, 15TL, 15TR, 16, 16C, 17B, 17T, 18B, 18T - 19T, 19B, 20T, 21T, 21B, 23, 24, 25T, 25CL, 25R, 25B, 26T, 26BL, 26BR, 27T, 27BL, 27BR, 28C, 28B, 29T, 29B, 30T, 30B, 31T, 31B, 32T, 32C, 32B, 33T, 33B, 34, 35T, 35C, 35B, 36B - 37B, 37TR, 37TL, 37C, 38BR, 42B, 43T, 47, 48T, 48B, 49BR, 49T, 49BL, 50B, 50T, 51TR, 51TL, 51B, 52TL, 52TR, 52B - 53B, 53T, 53C, 54, 55T, 55B, 55C, 56TL, 61TR, 61TL, 62T, 62BL, 62BR - 63B, 63C, 63T, 64T, 64B, 65T, 65B, 65C, 66, 67C, 67T, 67CL, 67B, 69B, 69CL, 70T, 70CL, 71TL, 71B, 71TC, 71TR, 71C, 73B, 74T, 74C, 74B, 75B, 75T, 77TR, 77TL, 77B, 81, 82B, 83B, 83T, 84, 85T, 85C, 85B, 86T, 86B, 87TL, 87TR, 87B, 88T, 88C, 88B, 89T, 89BL, 89BR, 90T, 90B, 91T, 91C, 91B, 92R, 92L, 93B, 93C, 93T, 94T, 94B, 95T, 95B, 96T, 96C, 96B, 108T, 108TL, 108B, 108CR, 109T, 109CL, 109CR, 109BL, 109BR, 110B, 111C, 111T, 114BL, 114BR, 115T, 115CR, 115BR, 115BL, 116T, 116CR, 116B, 117R, 117L, 118TR, 118TL, 118B, 118CR, 119T, 119B, 119C, 120T, 120B, 121T, 121B, 122T, 122CL, 122BL, 122BR, 123T, 123B.